DANCE AS A CATALYST

An Interdisciplinary Journey

MARGO K. APOSTOLOS

Kendall Hunt publishing company

Cover image © Shutterstock.com

www.kendallhunt.com
Send all inquiries to:
4050 Westmark Drive
Dubuque, IA 52004-1840

Copyright © 2023 by Kendall Hunt Publishing Company

ISBN: 978-1-7924-9158-0

Published in the United States of America

DEDICATION

This book is dedicated to the legendary dancer, choreographer, educator, author,
businessman, and my dear friend Joe Tremaine. . .
"5-6-7-8"

Contents

Foreword

Professor Apostolos's book *Dance as a Catalyst: An Interdisciplinary Journey* is an outstanding read not just for those interested in dance but more importantly for those of us who have considered dance only as entertainment or a fun activity on Saturday night. We worked with Dr. Apostolos over many years in our dance medicine clinic and she has helped us understand the specific needs of dancers with regard to injury and recovery, and she has worked with the athletic department at USC to help athletes better train and prepare. However, as this book demonstrates, these are just small subsets of the greater universe of dance. Dr. Apostolos helps us understand the importance of dance for the entire human experience. More importantly, she helps us understand how dance can open our minds to more creative thinking in all our endeavors.

Mark Vrahas, MD, MHCDS
Professor and Chairman, Department of Orthopaedics
Levin/Gordon Distinguished Chair in Orthopaedics in honor of Myles Cohen, MD

Acknowledgments

This book is the result of decades of teaching dance, conducting interdisciplinary research, and my education at Southern Illinois University Carbondale, Northwestern University, and Stanford University with great professors and classmates along the way. My teaching career has been filled with many wonderful connections, collaborations, some great discoveries and wonderful partners – from my early teaching at Glenbard North High School in Carol Stream, Illinois to Southern Illinois University – Carbondale, California Polytechnic State University – San Luis Obispo, Stanford University, and the past thirty-seven years at the University of Southern California.

My foremost gratitude belongs to my students. I continue to learn and grow by working with many bright, curious, eager young minds. Together, we continue to explore dance as a catalyst, making new connections, collaborations, and discoveries. Thank you to my colleagues and the Trojan Family for making the path so exciting and fun filled.

My sincere gratitude goes to Kendall-Hunt Publishers for an extraordinary experience in the process of writing this book. A special thank you to Senior Managing editor Angela Lampe for her continual support and encouragement and to Higher Education Publishing Editor Jennifer Wreisner. Jennifer worked intensely with me to prepare this book and assisted me in selecting many of the photos in this book. Photographer Mike Mandel contributed the unique time-motion photography of Robot Choreography. Mike's photos illustrate the aesthetic element of dancing robots. Thank you, Mike.

Dance Medicine has been an important collaboration with my colleagues at Cedars-Sinai Medical Center in the Orthopaedics Department and Physical Therapy. I am grateful to the members of the Orthopaedics Department, especially Mark Vrahas, MD, professor and chair of the Orthopaedics Department; Glenn Pfeffer, MD, Professor and Co-Director and CoFounder of the Cedars-Sinai/ USC Glorya Kaufman Dance Medicine Program, Guy Paiement, MD, Professor and Residency Director for Orthopaedic Surgery for their continued support of

Dance Medicine. A special thank you to my personal doctor, Cedars-Sinai surgical oncologist Allan W. Silberman, MD, PhD, Professor and Director of Clinical Affairs, Division of Surgical Oncology for his unwavering support and care over the past 36 years.

My close-knit circle of family and friends continues to surround me with their love and support for which I am forever grateful. Finally, my days are filled with the fond memories of the love, laughter, and guidance from my dear mother Jean Kezios Apostolos, my courageous father Gus Spero Apostolos, my loving brother (Spyro) Don Gus Apostolos, and my brilliant uncle Stothe Peter Kezios, PhD. They remain my everlasting inspiration each day.

About the Author

MARGO K. APOSTOLOS is a Professor at the University of Southern California in the Glorya Kaufman School of Dance and Co-Director/Co-Founder of the Cedars-Sinai/Glorya Kaufman Dance Medicine Program at the Cedars-Sinai Medical Center. She authored *Dance For Sports: A Practical Guide* and was previously awarded a NASA/ASEE Faculty Fellowship working in Space Telerobotics at the Jet Propulsion Laboratory with Caltech for her work in robotics and Robot Choreography. Dr. Apostolos earned her PhD from Stanford University, MA from Northwestern University, and BS from Southern Illinois University-Carbondale.

Introduction

> "Education is not the learning
> of facts but the
> Training of the mind to
> Think"
> —Albert Einstein, Theoretical physicist

The art of thinking may be underrated and overlooked in today's fast-paced internet world. *Dance as a Catalyst: An Interdisciplinary Journey* intends to be thought provoking for both dancers and non-dancers with a wide variety of topics. The information in each chapter relates to dance, presenting material for the reader to digest with analytical, critical, creative, and ethical thinking guided by your own imagination.

From an analytical and critical examination of dance topics to creative thought processes and ethical decisions, the reader engages in the practice of independent thinking with thought exercises at the end of each chapter. Thinking cannot be taught but rather practiced, and dance is our vehicle for this exploration. Interdisciplinary thinking is more than merely putting two topics together; rather, it is finding relationships to create new ideas and discoveries. Dance is a performing art, a participatory activity, a ritualistic and often symbolic expression of beliefs. Dance is an experience to enjoy whether a participant or an observer.

In Part I, an historical, philosophical, and sociological approach intends to expand thinking through learning about the past to better understand the significance of dance in society today. Dance, as nonverbal communication, establishes the global influences and universal settings throughout many eras in Chapter 1. From the performance stage to the village streets, studios, and schools across the

globe, dance is experienced by people of all ages, genders, and levels of ability. Dance is movement and movement is life.

From phenomenology, to aesthetics, and the Ancient Greek Philosophers, the prevalence of dance throughout the ages is part of philosophical investigations in Chapter 2. Philosophy and Dance opens the mind for interdisciplinary thinking and experiences for each reader. Critical thinking works with concepts of multi-sensory perception, examining works of art, criticism, taste, and judgment and the rhythm and harmony that parallels dance and society. Overviews of the works of Immanuel Kant, Bertram Jessup, Plato, Aristotle, and Socrates highlight this chapter with analytical and critical thinking explorations.

Thinking about dance guided by the philosophy of aesthetics and critical examination of works of art assist an observer in examining dance. The foundations of the great philosophers of Ancient Greece discuss the importance of dance in art, education, and physical training. Specifically, this chapter touches on the philosophy of Immanuel Kant's Aesthetic Theory and the foundation of dance in Ancient Greece. A look at Plato's *Republic* (Book IV) opens discussion of the fundamental aspect of dance in human development. Plato, Socrates, and Aristotle all include dance in their teaching and thinking. The importance of dance in education and sport training is regarded as essential in Ancient Greek society.

While this book is not an historical view of dance, Chapter 3 looks at the early beginning of ballet. The significance of the establishment of ballet as an art form in France contributes to the growth and spread of dance throughout the world. While dance exists throughout the world, the codification of dance is extremely important to the growth of dance as an art form. From the impact of the emerging fairy-tale ballets to the revolutionary shift to contemporary ballet and modern dance, the importance of the reforms of Jean George Noverre, the significance of impresario Serge Diaghilev, modern dance revolutionary Isadora Duncan, and Martha Graham, the mother of Modern Dance, open the way for the continuum of growth for dance experience. This chapter explains the spread of dance with the beginning of ballet to contemporary dance from Europe to America. The establishment of ballet sets a codification for dance that opens the way to teaching dance, allowing the spread of ballet across Europe. The aspects of analytic and critical thinking assist in understanding the world of both classical and contemporary ballet. The influence of classical ballet and the subsequent growth of contemporary dance and contemporary ballet emphasize the paramount role of dance in society. The aspects of analytic and critical thinking assist in understanding the world of both classical and contemporary ballet.

The idea that dance existed in ancient societies and is a prominent topic for the works of many of the greatest artists emphasizes the widely accepted and universal aspect of dance. Examples of visual art in the ancient worlds of Egypt, Greece, and Rome are depicted through the art of these societies. Examining how art depicts dance through the ages provides a visual timeline for the study of dance as an art form.

Part II highlights dance connections along our interdisciplinary journey. Dance, as an art form, looks at dance in poetry, visual arts and sculpture in this chapter. Viewing dance in visual arts and sculptures provides material for analytical and critical evaluation. Edgar Degas, Henri Matisse and Pablo Picasso are a few of the artists linking dance with the visual arts and sculpture are elaborated in Chapter 4. Poetry, identified in Ancient Greece as one of the Fine Arts, brings rhythm, expression, and emotion to our conversation. From the rhythmic meter of poetry, elements of mathematics subtly enter our discussion with the rhythms of the poet's words. Rhythm is about timing and sequence that may be visual and auditory and felt by both the performer and the audience, even linking mathematics and timing through dance and poetry.

Dance is a performing art. Chapter 5 looks at the production aspects of dance from costumes, lighting, and sets for many forms of dance from stage to street performance. By relating the ancient theatre, the French court ballets, and the emerging extravagant productions of the Classical Ballet era to the formulation of Martha Graham's theatrical productions, the importance of the elements in dance production emphasizes the totality of dance as an art form. This chapter looks at both stage and screen performances of dance with a focus on the costumes, lighting, and set designs. The integration of the visual arts and artists, as collaborators, looks at various artists and designers in collaboration with dance.

In addition, the expansion of dance to the screen is covered in this chapter from Busby Berkeley, Fred Astaire, Gene Kelly, and the Nicholas Brothers to the advantage of utilizing the camera to enhance dance performance. Chapter 6 introduces Dance Photography and Architecture. The art of capturing motion in a single frame photograph presents opportunities for everyone with a camera phone. In this chapter, the creative discovery of subject, setting, and action challenges the reader to take their hand at creating dance photography. People and places offer the setting and architecture presents outstanding challenges in every city and town. The reader is encouraged to "go on location" and create a collaboration of dance, architecture, and photography.

Part III provides examples of collaborations illustrating the products of great connections. Chapter 7 opens the discussion of collaborations with the relation of dance, art, aesthetics, and industrial design at the Bauhaus School of Design in the middle of the 20th century. The work in kinetic art and mechanical art in motion follows suit in this chapter. Actually, the works of the Bauhaus and kinetic art lead into the emerging blend of dance and technology. Chapter 8 introduces the elements of technology, robotics, motion capture, mixed reality, and augmented reality to bring dance into the twenty-first century. The expansion of work between dance and animation is featured in this chapter.

Chapter 9 returns to the Ancient Greek concept of mind and body training through dance with a greater discussion of the importance of dance as physical training for health and fitness through dance. The physical benefits for both the

mind and body are explained in greater depth in this chapter. Fitness is a benefit of dance training. Early dance education in the United States was housed in physical education programs throughout the country. The physiological benefits are reinforced in alignment with the early teachings of Plato and training of athletes in Ancient Greece.

Finally, Chapter 10 takes dance beyond the steps, combining dance with various interdisciplinary topic discoveries. Many of these topics are the result of the creative, critical, and analytical thinking of my students. The collaborations are out there, just open your mind and use your imagination.

Throughout the book, each chapter introduces a concept to initiate the thought process in relation to dance and includes thought exercises for the reader. Musings, my reflections on the chapter, close each chapter. The wide variety of topics covered in this book demonstrate the power of dance as a catalyst for interdisciplinary thinking. Facts provide valuable information, but the real learning comes from thinking.

PART I

SOCIOLOGICAL, PHILOSOPHICAL, AND HISTORICAL THOUGHTS

Dance as a Catalyst

1

Dance is movement and movement is life, which makes dance a perfect vehicle for our interdisciplinary journey. Let dance become your catalyst by providing an impetus for new ideas and change. This popular and powerful movement of human expression enjoyed by both participants and observers whether professional, amateur, or recreational each with a unique and personal approach. This chapter introduces the concept of dance as nonverbal communication and a cultural experience for many to enjoy.

Movement exists around the world and throughout the centuries. Dance may be learned and rehearsed or spontaneous and improvisational; nonetheless, dance provides both communicative and artistic experience. An understanding of the concept of dance followed by a brief look at communication, culture, settings, styles, and choices guides the opportunity for independent thought exercises to expand your thinking. Remember this is a personal experience and keep it tailored to your interests and knowledge.

CONCEPT: DANCE

Legendary modern dance icon Martha Graham states in her autobiography, Blood Money, "I feel that the essence of dance in the expression of man – the landscape

of his soul."[1] American Philosopher and aesthetician, Suzanne Langer makes reference to art in general. Art is the creation and forms symbolic of human feelings.[2] To paraphrase the words of Martha Graham with Suzanne Langer's definition of art, "dance is to say with your body (movement) what you cannot say with words."

Throughout the world dance is an experience from the stage to the streets, with people of all ages dancing to their own rhythms in the everyday movements of life. The individual rhythmic patterns of diligent workers, children at play, or even movements in nature often serve as dance metaphors for movement patterns; that is, stars "dancing" in the sky, raindrops "dancing" in the puddles, or rhythms of the animals "dancing" in natural surroundings. Letting your mind open to observe the movements of dance in your surroundings will enhance your ideas of dance.

COMMUNICATION AND CULTURE

Dance, as nonverbal communication, speaks through the universal language of movement without words. Dance is an expressive with an aspect of emotion that translates through movement for both the performer and the observer. Dance, as nonverbal communication, speaks through the universal language of movement without words. Anthropologist, scholar, and author Judith Lynne Hanna explains her perspective from the study of both participant and audience being so impactful because the connection is a "live exchange."[3] Clearly, words and statements may state an emotion but the actions of human movement reflect feeling that may be hard to disguise.

Dance becomes a great way to learn about the people of a culture or region. Observing dances of a particular culture lends way to a better understanding of beliefs, customs, strengths, and differences among the people. However, the meaning of gestures and particular movements is significant and may vary across cultures. Remember, dance communicates through movement without words or common verbal language.

Clearly, one way to learn about the people and their culture is to learn about their dance. Anthropologists learn about various cultures by studying the dances of the people. Legendary dancer and choreographer Dr. Katherine Dunham was a pioneer in the study of dance/anthropology with her extensive work incorporating African American, Haitian, Caribbean, South American, and African dance in her work. Clearly, one way to learn about the people and their culture is to learn about their dance.

STYLES AND SETTINGS

Dance offers a variety of styles and each individual has the privilege to select favorites whether performing or watching in either public or private settings from concert dance to participatory dance to ritual dance and commercial dance. Some of the most popular types of dance include: ballet, jazz, contemporary/modern, hip-hop, ballroom, region/ethnic/folk, swing, and square dance.

The contributing elements in dance performances include the setting, the music, costumes, movement patterns and sequences, musical tempo, and harmony. Enjoying dance involves visible elements from the movements of the dancer often enhanced with casual or elaborate costumes, set design, scenery, lighting, and props. In addition to the visual experience, dance usually involves sounds or music to accompany the dance becoming a pivotal part of the experience. Dance may be trained and rehearsed or spontaneous and improvisational. Nonetheless, the result is an experience of expression that impacts the emotions for people to enjoy. Dance is enjoyed in both private and public settings from concert dance, to participatory dance, to commercial dance, and to ritual dance.

Participatory dance is enjoyed by the performers whether they are professional or recreational performers and may be staged or performed impromptu, almost anywhere. Quite often the joy of participatory dance is for those performing the dance whether with or without an audience.

Concert dance has a setting staged for an audience that may be either formal or informal and often following a specific program, although not always in a theatrical setting. The concert dance often has a setting that focuses audiences' attention on the dance performance whether on a stage or highlighted for viewing from the audience. Usually, concert dance features a specific program for the performance but may be impromptu or less formal.

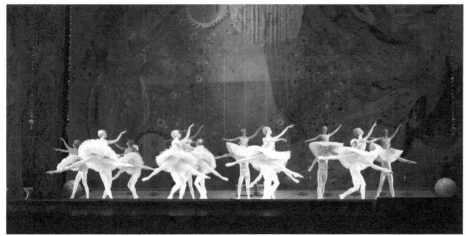

Caftor/Shutterstock.com

Concert Dance

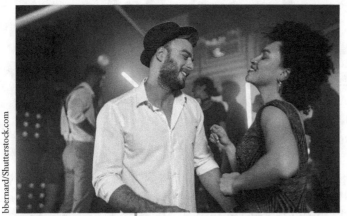

bbernard/Shutterstock.com

Participatory
Dance

Ken Durden/Shutterstock.com

Commerical
Dance

Participatory dance is enjoyed by the performers whether they are professional or recreational performers and may be staged or performed impromptu or even spontaneously. Many people enjoy participatory dancing at parties, nightclubs, and even in the privacy of their own living room. The joy of participatory dance is often for those performing the dance with or without an audience experience the joy of dancing.

Commercial dance carries various definitions these days in many different settings from film, video, advertisement, and promotional work, with sheer entertainment often a goal. Today, a variety of dance styles are identified as commercial dance with a combination of styles from hip-hop, contemporary, and jazz in a visually exciting and entertaining performance. From the performances of dance teams to the stages of Las Vegas, commercial dance continues to entertain and capture the attention of the viewers. The appeal of dance is a great marketing tool and again the universal, nonverbal communication of dance appeals to many people globally.

Cultural settings around the world feature dance rituals with specific meanings and beliefs attached to the dance sequences. These rituals carry deep meaning within a culture, which lend way to a better understanding of a particular culture with significant meaning for the musical accompaniment, choreography and patterns, outcomes and settings. Dance rituals are an excellent way to learn about a particular culture.

OBSERVING DANCE

An understanding of dance across various cultures begins with the observation of the movement and absorbing the visual elements and structure of the movement. Each observer makes an individual interpretation about the dance based on the setting and the purpose of the dance. Who is the dancer and what is the style of movement, music, costumes, props, scenery, and lighting are great questions. Understanding the cultural context of dance in a particular society provides a greater insight into a particular part of society. You will observe and analyze the dance from your own perspective. Observational questions may include: who is dancing, what are they dancing about, what is the meaning of this experience to the performers, where are they dancing, what is the style and the setting?

The observer finds the dance experience through the lens of their eyes based on taste, judgment, and experience. Interpreting dance involves both form (structure of time, content, and function) and context (historical, period, within a culture). The observer interprets the style and meaning of the dance by often finding core characteristics, basic styles of the movement, and understanding the significance of the dance in the cultural context.

Enjoying dance as an observer includes evaluating what you see in the dance performance. A few points guide the observer through the experience including: the criteria for the choreographer such as: training, experience, creativity, and previous works. Also, the criteria for the dancers include technical skill and creative expression through movements. Each person observing dance has an opportunity to express aspects of dance criticism, as a result of the performance.

TASTE AND JUDGMENT

Professional dance critics review dance to heighten the experience for the audience and the general public. A positive review may encourage others to see the performance, while a negative review may keep people away from the performance. Most importantly, criticism is based on taste and judgment of the observer and may be either positive or negative. These personal and intimate elements of taste and judgment develop and evolve with the more exposure and experience of the dance observer.

Educated taste comes from experience, understanding, and appreciation for the art form. Keeping an open mind and broadening the range of your experiences will sharpen your judgment and refine your tastes. Most importantly, the critic must substantiate their statements of taste and judgment with specific examples to support the statement. As you observe dance, simply ask yourself: Why did I enjoy this performance? Did the choreographer present ideas through movement creatively?

Bertram Jessup, philosopher and aesthetician, explains the role of an individual's personal taste and judgment in both viewing and evaluating art.[4] Remember, the goal of dance criticism whether amateur or professional is to sharpen an image of the performance through views, reflections, and evaluating the dance and reflecting on a more personal and critical impact of how the work "moved" you through your personal emotional reactivity. A professional dance critic may sway the audiences' experience with their review of a performance. In addition, the collective conscience of the audience may influence the immediate reaction through applause, laughter, or intermission conversation. Many people may agree the performance is either good or bad, and the audience may be influenced before even seeing the show. It is crucial to remember that we all have the privilege of taste and judgment in either liking or disliking something. Just remember to support your point of view with examples to verify your statements.

THOUGHT EXERCISES FOR CHAPTER 1

- Find dance in your immediate and personal environment whether live, recorded, on the internet, or somewhere unlikely. Keep your eyes open and jot down a record of these dance experiences. You may include unlikely observations of dance as a metaphor.
- View two or more live or recorded experiences of dance from a specific culture and observe and explain the visible elements. Keep in mind: who is dancing, where are they dancing, what are they dancing. Keep in mind the aspects of dance as nonverbal communication.
- Tell me about a dance that you experienced and convince me whether I should share this experience or not bother to share the experience. Be sure to validate your impressions whether good or bad. Remember this is based on your taste and judgment. Be descriptive and sharpen the image of the performance.
- In a creative exploration, use a simple everyday (pedestrian) walk to capture your various emotions: walk as if you are happy, sad, tired, angry, confident, frightened, hurried, or lazy. Just experiment with the interpretation of emotion through movement (no dance skill required).
- How may dance enhance or support ethical behavior?

MUSINGS

The intent of these exercises is to begin the thought experiences of analytical, critical, creative, and ethical thinking. No one answer is correct, with each individual exploration being unique and personal. A common goal is to experience dance and reinforce that dance is everywhere and dance is life. Dance, as nonverbal communication, crosses cultures allowing each person to make individual creative choices in aesthetic appreciation. Finally, dance promotes self-discipline through learning of dance for people whether amateur or professional. Dance is an integral part of play according to Huizinga: the relationship is one of direct participation, almost of essential identity. Dancing is a particular and particularly perfect form of playing.[5] No doubt, dance is for all and dance is life.

ENDNOTES

1. Martha Graham, Blood Memory, Doubleday New York, 1991 p. 6
2. Suzanne K. Langer, *Feeling and Form: A Theory of Art developed from Philosophy in a New Key* (London and Oxford: Routledge & Kegan Paul, 1953), 40.
3. Judith Lynne Hanna, *The Performer-Audience Connection* (Austin: University of Texas Press, 1983), 6.
4. Bertram Jessup, "Taste and Judgment in Aesthetic Experience", *The Journal of Aesthetics and Art Criticism* 19, no. 1 (Autumn 1960): 53–59.
5. John Huizinga, *Homo Ludens: A Study of Play Elements in Culture* (Boston: Beacon Press, 1959), 165.

Philosophy and Dance

> Beauty is in the heart of the beholder.
> —Margaret Hungerford (Author)
> 1878 novel, *Molly Brown*

Dance, as an art form, offers opportunities for your analytical, critical, creative, and ethical interpretations. Each person maintains the privilege for their own individual taste and judgment with regard to dance and art. This chapter touches on aesthetics and looks at what is beautiful in art and beyond. Please keep in mind that this is neither a philosophy text nor is the author a philosopher, but together we will examine thoughts about dance and art.

A brief overview of aesthetics introduces the ideas about art and what may constitute a work of art. The question of beauty and a work of art remains a debate for centuries from the great philosophers from Plato, to Immanuel Kant and even to the present-day coffee shop conversations. Exactly what comprises a work of art may range from the simplicity of nature to the refined professional arts of dance, music, fine arts, sculpture, to the drawings and works of professional and amateurs. One thing is for certain: art may be valued by artists or observers, with the emotional effect of art being a personal experience.

CONCEPT: AESTHETICS

The Encyclopedia of Philosophy discusses aesthetics as "the branch of philosophy that is concerned with the analysis of concepts and the solutions of problems that

arise when one contemplates aesthetics objects. Aesthetic objects, in turn, comprise all the objects of aesthetic experiences; thus, it is only after an aesthetic experience has been sufficiently characterized that one is able to delimit the class of aesthetics objects."[1]

The topic of aesthetics provides a start for examining dance as an art form and the simple aspects of beauty and art, that is, finding a dance experience that moves your emotions whether professional or amateur, on the stage or in the streets, whether in a group or in solitude. Images of both nature and art provide material for finding something that strikes your emotions.

Keep in mind that every experience is personal and intimate. The aesthetic element in dance is an experience for the choreographer, the dancer, and the audience. The obvious characteristics include rhythm and patterns that create movement qualities of flow, shape, and timing to create aesthetic elements of movement. Choreography, the art of making dances, uses dance as a series of rhythmic motions in time and space to express ideas through movement. In our work of looking at dance as an art form, the aesthetic characteristics of movement in dance are identified and interpreted by defining various patterns of movement for the artist and the observer. The audience/observer is part of the aesthetic experience, too. The choreographer designs the movements, the dancer performs the choreography, and the audience perceives, interprets, and responds to the dance.

Ideally, an aesthetic experience should "move" you in a positive way. A moving experience often generates a unique emotional response. No one intentionally views dance to experience a bad or negative performance, although a particular dance experience may not be suited to your taste. Keep in mind that taste can be acquired and refined through expanded experiences and by keeping an open mind. Your tastes will become refined over time and increased exposure to dance of all styles and settings.

In your dance observations or performances many different sensory experiences may be ignited, with some experiences more powerful. Your body and mind will respond in some way based on your feeling and forming your interpretations. Your critical response may be favorable or unfavorable; however, there is essentially no right or wrong aesthetic experience. Once again, taste is personal and becomes refined through experiences, and judgments may vary. Furthermore, dance criticism is based on taste and judgment.[2]

PHENOMENOLOGY AND MULTISENSORY PERCEPTION

Phenomenologists study of experiences and links the mind and body and often the tangible and the intangible. In many ways, dance embodies a phenomenological experience for the choreographer, dancer, and audience that becomes individually personal and intimate. This multisensory experience is recognized in the

body and mind of the individual. A choreographer creates the dance in the mind and embodies the emotion through movement of the dancers, which is perceived by the audience in a state of kinesthetic synesthesia or merging of these sensory modalities. The phenomenology of perception merges these tactile, kinesthetic, and optical senses to create an experience of each individual. An artistic experience is phenomenological: it is seen, heard, or felt and we respond. In dance, physical movement creates the work of art that integrates feelings and emotions through interconnections of our senses and proprioceptive recognition.

Synesthesia in art is found in a work of art that may be harmonious or dissonant. Just let your body respond and trust your feelings. Kinesthesis lets your sensory system take over through your conscious body perception and feelings of your own body in physical space. This experience is physiological, with muscles, tendons, nerves, and internal receptors acting and reacting in a way that is personal and unique to each individual. By example, what I may feel can only be felt by me. If I feel happy and you also feel happy, an individual will never know the sensations the other person is exactly feeling. Words can merely describe a feeling but words cannot replicate a feeling. Our individual complex sensory systems are activated with dance experiences and the cross-modal connections (see, hear, feel) leaving a sensory impression as a feeling quite often in response to the movement.

In dance, emotions are expressed through movement with a creative abstraction of ideas and feelings. Dance frees the one to explore individual feelings to connect with sensations of the body in space and body awareness. This personal experience assists in training an individual to identify and establish body awareness and feelings relating to their personal movement capabilities. These variables represent a phenomenological aspect of being a sensation owned by an individual and truly a personal and intimate experience.

Philosopher Susanne Langer's writings on art and dance include the study of symbolic meaning of the work of art, as art is an intangible not considered to be quantifiable. A work of art may be represented through discursive symbolism such as words or language. Presentational symbolism is represented through pictures, objects, and bodies in motion such as dance. Music, a vital part of dance, uses sound as artistic symbolism, creating a feeling for the listener with sound. However, music is recorded with symbols that create the sound.[3]

Does dance have to be beautiful to be art? Is a work of art that which is on display in a gallery or performed on stage? Can we find a work of art in nature or does it have to be framed and designated as art? Nonetheless, beauty moves you through a sensory experience. Just as we can see elements of nature in the sunsets, snowfalls, and sounds of the forests, they can evoke a moving experience to some and the framed photos or painting of nature declared formally as art. In the words of philosopher Immanuel Kant, "A natural beauty is a beautiful thing; artificial beauty is a beautiful representation of a thing."[4]

Natural sunset

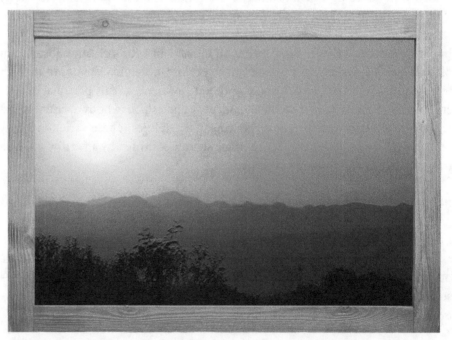

Sunset Framed

Whether in nature or in "art" these are aesthetic experiences in a multisensory dimension for the observer. An aesthetic experience moves the observer or creator with emotions that are personal and intimate feelings. The mind and body are responding to the experience.

Kant refers to taste and judgments in relation to aesthetic and cognitive perception, "the ground of this this pleasure (in the beautiful) is found in ... the purposive harmony of the object (whether a product of nature or of art) with the mutual relations of the cognitive faculties (the imagination and the understanding), a harmony which is prerequisite for very empirical cognition."[5] Your reaction to art may hold personal reflections attached to an image.

Consider the beauty of a pristine white snowfall and muffled silence of the freshly fallen snow. Yet, consider the effects of the snowfall in a personal perspective like the shoveling of heavy snow, or the after-effects of dirty snow piled up along a road in the frigid temperatures of winter, or even being stranded in a heavy snowfall. These visuals of nature often carry personal emotions that may view the snowfall as anything other than being a beautiful work of art. Nature is full of many aesthetically charged events both auditory with the sounds of rain, chirping birds, or even the silence of a dense forest in stillness.

Beauty and art may be found in the unlikely places. An individual may be moved and find an aesthetic experience in what others may consider unappealing. Consider a photo of junk that may appear harmonious in a frame and displayed in a gallery. Some observers may see art and others may see junk. Keep in mind that when it comes to art, there is no right or wrong, as someone may see dissonance to be an aesthetically pleasing experience and the harmonious work may not be appealing to a particular individual.

HARMONY: ANCIENT GREEK PHILOSOPHY

Ancient Greek philosophers saw beauty and value in the arts, which was an integral part of life in that era. Greek philosophers Socrates, Plato, and Aristotle recognized the arts in society with the mind/body dualism as a theme and formulated art as part of education. Plato's Republic discusses art in education of the mind and body identifying the rhythm and harmony of each individual as a reflection of the state of the society. If each individual is at harmony with their mind, body, and spirit, then society in general may be more harmonious. This may appear to be a grandiose concept but the notion; perhaps the idea of personal harmony being a reflection on society may be something to consider in today's world affairs. In Book IV of Plato's *Republic*, dance is explained to be part of education in Ancient Greek society for the athletes and warriors. The athletes were held to the highest regard in Ancient Greece and those athletes were the soldiers who protected the territories.

The Ancient Greeks valued the total development of the athlete by blending art and science, work and play, mind and body in society and sport. To Aristotle, the health of the mind was dependent on the health of the body, linking both art and science in his thinking and writing. Health and virtue contribute to this balance and become necessary elements in achieving the pure symmetry of body

and spirit. In Book IV, Plato further discusses the elements of wisdom, courage, discipline and justice along with rhythm and harmony both in society and in individual actions for athletes. Their training included balancing the mind, body, and spirit to benefit the individual and the state, with the expectation that such training would in turn create exemplars citizens. Athletes held a powerful role in society beyond the competitions and contest and were held in high esteem by the Ancient Greeks. Their training included a balance of the mind, body, and spirit to benefit the individual and the state with expectations to become exemplary citizens. Education of the physical and education through the physical were common themes in Ancient Greece. The harmony found through the unity of each individual's mind, body, and spirit may collectively reflect into society. Specifically, Socrates supports dance as training to find that harmony and rhythm from within the individual.

Now, as we were saying, isn't it a mixture of musical and physical training that makes these elements: concordant, tightening and nurturing the first with the fine words and learning, while relaxing, soothing, and making gentle the second by means of harmony and rhythm?[6] (Socrates from *Plato's Republic*, Book 4).

These Greek ideals present an interesting perspective on the significance of dance in education and society. The educational experience of dance reaches a deeper dimension of self-discovery beyond the physical to the intellectual and emotional dimensions of an individual. The fundamental movements of dance provide a vehicle for training the individual by reaching beyond physical movement by relating feeling to movement; connecting the mind, body, and spirit in pursuit of and state of personal harmony.

Dance training is an individual experience, although it may be shared with a group. The idea of a united body, mind, and spirit is rooted in Ancient Greek society, as demonstrated with the Olympic athletes in training, performance, and stature. The dance training for athletes in Ancient Greece reinforces rhythm and harmony for each individual athlete and in the union of the team. Kinesthetic awareness, rhythmic awareness, and the subsequent balance (pure symmetry) are the contributing factors to effortless movement. The beauty of a trained dancer is often viewed as seemingly effortless in performance. The dancer trains to move efficiently via the elements of grace, timing, rhythm, and fluidity to the movements. Similarly, a unity of the athletes sharing a movement experience in the dance studio creates a harmonious atmosphere for the team, essential to the camaraderie in sport.

Education through dance offers an opportunity for personal exploration of body movement based on anatomy, the physiology, and the psychology. Dancers experience a motor-neural connection, as a synthesis of feelings and action in movement. Dancers work to perfect technique, although in dance the mechanical aspects of movement are coupled with feelings and emotion. Movement in dance

represents the union of intellectual processes with personal experience and values such as hard work, discipline, and dedication working toward a personal mind and body harmony.

The pure symmetry of the human body and spirit is part of a duality that echoes in dance. The mind/body element is enhanced with the development of kinesthetic awareness and rhythmic awareness in the dancer and the athlete. It is through a motor neuron connection that we train for in dance and in transitions of movements that connect to produce fluid movement connected seamlessly from point to point. The mind and body connect in performance through the expressive experience for the performer while the observer may be moved by the dance performance.

THOUGHT EXERCISES FOR CHAPTER 2

- Describe an experience that moved your emotions.
- Describe a moving experience with regard to a multisensory experience of kinesthetic synesthesia.
- Find an example of dance in nature.
- Find or create a visually harmonious experience in your everyday environment.
- Can a dissonant work of art be an aesthetic experience? Can you find an example of dissonant art?
- How does dance fit into the education of an individual in today's society?
- In what way may a dance experience enlighten ethical behavior?

MUSINGS

Plato's notion of dance in education considers dance to be fundamental to society. Thus, dance is not a separate curriculum but rather essential to all of education.[7] These personal, intimate, physiological and psychological effects of movement are the basis for analytical, critical, creative and ethical thought. Everyone has the ability to find and enjoy their own dance, trained or untrained just follow your feelings and let your body move freely. Dance may be found all around our environments whether a dancer moving elegantly across the stage, a bird in flight soaring across the sky, or an athlete in effortless performance. Whether you find beauty in a work of art, sport, or in nature, identify those aesthetic experiences that "move" your sensations. Remember, the beauty is in the heart of the beholder.

ENDNOTES

1. Paul Edwards (Editor in Chief), *Encyclopedia of Philosophy, Volume One* (New York and London: Macmillan Publishing Con., Inc. & The Free Press/Collier Macmillan Publishers, 1972), 35.
2. Bertram Jessup, "Taste and Judgment in Aesthetic Experience," *The Journal of Aesthetics and Art Criticism* 19, no. 1 (1960 Autumn): 53–59.
3. Howard Gardner, "Philosophy in a New Key Revisited: An Appreciation of Susanne Langer," from *Art, Mind, and Brain: A Cognitive Approach to Creativity* (New York: Basic Books, 1982), 48–52.
4. Immanuel Kant, *Critique of Judgment*, trans. J. H. Bernard (New York and London: Hafner Press, A. Division of Macmillan Publishing and Collier Macmillan, 1951).
5. Donald W. Crawford, *Kant's Aesthetic Theory* (Madison: The University of Wisconsin Press, 1974), 78.
6. C.D.C. Reeve translation, *Plato: Republic* (Indianapolis and Cambridge: Hackett Publishing Company, Inc., 2004), 130.
7. Graham Pont, "Plato's Philosophy of Dance," 267–281, from library.efdss.org.

Ballet and Beyond: Classical and Contemporary

Dance design is not simply one element, it is that without which ballet cannot exist. As aria is to opera, words to poetry, color to painting so sequence in steps— their syntax, idiom, vocabulary—are the stuff of stage dancing.
—Lincoln Kirstein (American writer)

To many dancers and choreographers, ballet training is a foundation for many forms of dance. Although dance is constantly evolving with new hybrid dance forms, ballet holds a significant place in technique, production, and performance. In examining dance as an art form, an understanding of the significance, origin, and development of ballet deserves attention. A common vision of dance often used in marketing, advertising, and the media is the image of a ballerina in a tutu with pointe shoes. This chapter intends to provide a brief overview of the early beginning of ballet rather than an in-depth study of dance history.

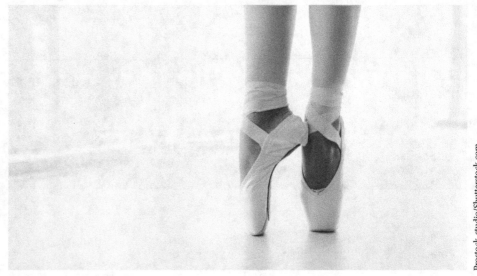

Prostock-studio/Shutterstock.com

Ballerina En Pointe

CONCEPT: BALLET

The word "ballet" takes on three distinct meanings: as a technique, as a company or troupe performing before an audience, or as a production. Let us keep those distinctions in mind in our overview that begins with ballet as technique.[1]

TECHNIQUE

While dance has been a part of human life for centuries, ballet provides a codification for dance that remains largely universal in training and choreography. Ballet provides nonverbal aspects of dance communication through a common vocabulary, step sequences, and body postures. Many teachers and choreographers communicate with an understanding of a fundamental dance terminology which is often based on this ballet terminology.

In addition to the specific steps and positions of the feet and body, the posture and the discipline acquired by the dancers are essential to their training. The simple fundamentals of individual discipline and body symmetry are significant to ballet and transferable to other dance forms and movement sequences. Another benefit of ballet training is the careful attention to posture and alignment of the body from the head, neck, and torso to the carriage of the arms.

PRODUCTION

The growth of dance as an art form flourished with the emergence of elaborate ballet productions. The importance of ballet throughout the ages lies in both the

technique and the performance. Ballet as a production was established in France in 1581 with the Ballet Comique de la Reine. The foundation of movement though dance existed throughout the world in various forms of humans and nature moving rhythmically.[2] Dance flourished across Europe from the foundation supported by France's King Louis XIV.

DANCE COLLABORATIONS

King Louis XIV established the Royal Academy of Dance in the 1700s, which included both ballet and opera merging music and theatre. The young "dancing king" hired the best musicians and teachers to begin his prestigious school for dance and music training. The artistry of ballet was the product of several artists: Jean-Baptiste Lully, Pierre Beauchamp, and Molière worked together with King Louis XIV. Beauchamp was the ballet master and Lully the composer built a strong music and dance collaboration. To strengthen the interdisciplinary link, Molière a poet, playwright, and actor broadened this interdisciplinary scope of the academy.[3] This interdisciplinary union of dance, music, and theatre focused on training and performance, with dance emerging as art form being performed for an audience on a stage.

At the Royal Academy of Dance, the codification of dance was perhaps one of the greatest contributions to universal communication of dance and dance training. The dance positions and step sequences were given specific names, which continue today as a universal language of ballet dance.

Pierre Beauchamp was a ballet master of the court ballets and was Louis XIV's private teacher. Beauchamp's technique established the five positions of the feet, which are still standard in ballet today. This was the beginning of codifying and notating dance with to track the dance and the footwork.[4]

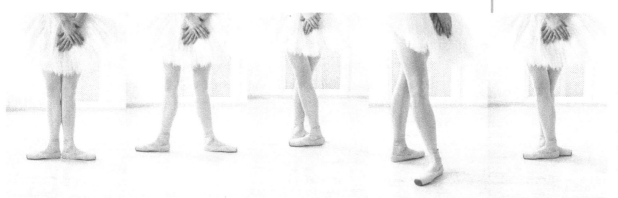

Prostock-studio/Shutterstock.com

Ballet 5 positions of the feet

Beauchamp worked with playwright Molière to create Comédie-ballet, which merged a play with a court ballet, a resemblance to musical theatre. These Comédie-ballets brought dance from the elite to the street for many to observe and enjoy. Molière was the director and writer, Beauchamp the choreographer, and Lully the composer. Clearly, the strength and force of dance as an art form lie within brilliant collaborations.

Dance, as communication, remains the focus of this new art form but performance and technique were highlighted. The young 'dancing king' took a special note to fashion and dance with costumes and theatrical elements which were important elements of the dance performance. Ballet told stories through the art of ballet dance with attention to theatrical elements. Jean George Noverre reformed the art of ballet into the dramatic expressive storytelling with specific themes, plots, and stories. The unification of the storytelling was emphasized through the movement, expressions, gestures, costumes, scenery, and props. Noverre created Ballet d'Action, or these dances of action that were greater than mere virtuoso—truly artistic collaborations with a central theme and focus.[5]

France may be credited as the birthplace of ballet, but this popular dance forms rapidly spread across Europe to Denmark and Bourneville's Royal Danish Ballet. Classical ballets of *Swan Lake, Sleeping Beauty, Cinderella*, and *The Nutcracker* remain iconic favorites to audiences of all ages across the world. The popularity of these iconic ballets continues today. Today, both classical and contemporary dance continue to perform these fairy-tale stories and often with a modern twist. Choreographer Matthew Bourne adds a contemporary style to Swan Lake with a gender twist and his update to Cinderella brings that story into 1940s World War II setting. Choreographer Mark Morris updated the classic Nutcracker to a more contemporary style, movement, costumes, and set design.

CLASSICAL TO CONTEMPORARY

As ballet spread across Europe, inevitably ballet found its way to America. Serge Diaghilev established the Russian Ballet Russe which eventually moved across Europe to England and from England to the United States. The Ballet Russe notably highlighted the dancing of Nijinsky and the choreography of George Balanchine and artist Pablo Picasso designing costumes and sets for the Ballet Russe. Diaghilev, known as an impresario, transformed ballet in a remarkable way for the twentieth century. As a true impresario or entrepreneur, Diaghilev gave ballet a stronger cultural context that related to the audiences. "The Ballet Russe left its mark on fashion, design, and entertainment"[6] without the advantages of advertising, the internet, or social media.

Truly, dance as an art form comes to the United States in the form of classical ballet and emerging as a widely popular international art. With Diaghilev's vision,

ballet attracted audiences of not only the rich and privileged of society but also ordinary people merging intellectuals, artists, and select public.[7]

Not long after the arrival of Classical Ballet to the United States in the early twentieth century did the beginnings of Modern Dance begin to emerge. The theatrical dancing of Loie Fuller with her costumes and lighting brought dance production to a new level. In the Serpentine Dance of 1892, Fuller used fabric and lighting to create a new artistic vison. Her innovations may have been the first look at mixed media.[8]

The rebellious Isadora Duncan opposed the restrictions of ballet from the rather unnatural turn out of the hips, the codification itself, and the fairy-tale nature of the story ballet. Isadora promoted natural movement emphasizing free expression, parallel hips, and free-flowing costumes; thus, the seeds of modern dance were planted. Isadora was free spirited and "her dances were more concerned with feeling than with form; she improvised a great deal and never codified a set of steps into formal systems."[9] Perhaps, Isadora's style, thinking, and art make her better suited for society today.

While Isadora freed the dancer from what many considered the artificiality of ballet, Martha Graham is said to be "the greatest artist of American modern dance and one of the molders of the age."[10] Graham's work was emotional, artistic, collaborative, and theatrical, making her not only a choreographer and dancer but also expert in lighting and costume design including her collaborations with composer Louis Horst and artist Isamu Noguchi.

Graham developed her own training technique that was both physically demanding and emotionally expressive for both dancers and actors.[11] This technique involves specific training by certified Graham teachers. The early generation of Modern Dancers included the magnificent Martha Graham, Merce Cunningham, Ruth St. Denis, and Ted Shawn, which led the movement to free the dancers of the constraints of classical ballet. These early modern dancers were among others that laid the foundation for the contemporary dance that we know today.

Martha Graham established a strong collaborative team with composter Louis Horst and sculptor and designer Isamu Noguchi. Dance, as an art form, rose to new heights with the brilliance of this team. No doubt, Graham's brilliance was in the theatrical representation of dance communicating emotion and meaning through her choreography and technique. The precision of her technique and attention to detail may have paralleled King Louis, although she transformed the dance from the world of strict classical ballet to a freer form of dance. The successful collaborations of King Louis XIV and Martha Graham illustrate the value of interdisciplinary work with dance as a catalyst.

THOUGHT EXERCISES FOR CHAPTER 3

- Observe a ballet class and take note of the rigor, discipline, and conformity of the dancers. Try to assume the five ballet positions of the feet with hips turned out and note the feelings or constraints in your body.
- Can you find elements similar to ballet in other dance styles? Take note of similarities and differences in the technique and style of movement.
- Can you find images or references to ballet in the media and advertisements, or public information messages?
- If Isadora Duncan were present in our society, what popular musical group could you image incorporating her dance, costumes, and lighting in concert?
- Describe a story or fairy tale that you would like to see transformed into a dance story either classical or contemporary style.
- Do you find ballet today to be available for all people? Are there still financial, body image distortions, equity, diversity, and inclusion constraints?

MUSINGS

Ballet whether in reference to the technique, the production, or the dancers provides a codified language for dance. The syntax, set of rules, the idiom, mode of expression, or the vocabulary or words that represent the step sequence accentuate the importance of the early beginnings of ballet. The ballet in France in the 1500s, Louis XIV in the 1700s, and the fairy-tale ballets of the 1800s gave dance an impetus through organization and codified language for communication igniting the global spread of dance. Dance collaborations merging great artists and teachers have thrust dance forward throughout the centuries.

The foundation of ballet nestled in the aristocracy of France with performances focusing on the elite members of society raising issues today of equity and inclusion. The growth and professionalism of ballet as an artistic experience for the audience produced extravagant performances with elaborate costumes, scenery merging the arts of dance, music, and design on stage. Thus, attending a ballet performance may be quite costly as the ticket prices must offset the expenses of the production and dance company expenses. Dance training costs money, too. A dancer may be unable to take dance classes regularly, due to the cost. The physicality of dance and emphasis on body image often result in health issues of eating disorders and psychological problems for dancers.

ENDNOTES

1. Walter Terry, *The Ballet Companion* (New York: Dodd, Mead & Company, 1968), 1.
2. Ibid., p. 4.
3. Ibid., p. 86.
4. Ibid., p. 9.
5. Ibid., pp. 88–89.
6. Lynn Garafola, *Diaghilev's Ballets Russes* (New York and Oxford: Oxford University Press, 1989), xii.
7. Ibid.
8. Jack Anderson, *Ballet and Modern Dance: A Dance Horizons Book* (Princeton, NJ: Princeton Book Company, 1992), 166
9. Joseph Mazo, *Prime Movers* (New York: William Morrow and Company, Inc., 1977), 37.
10. Ibid., p. 53
11. Ibid., p. 54

PART II
DANCE CONNECTIONS

Visual Arts, Sculpture, and Poetry

4

> Mathematics is, as it were, a sensuous logic, and relates to philosophy as do the arts, music, and plastic art to poetry.
> —Karl Wilhelm Friedrich Schlegel (German poet)

Dance is linked with other expressive art forms in this chapter. The visual images of dance on ancient artifacts to the merging of dance with other arts; such as painting, sculpture, poetry, and even a connection with mathematics. Traditionally fine arts included: sculpture, painting, dance architecture, poetry, music, and drama. Art historian, Thomas Munro further categorizes arts of simultaneous perception with architecture, sculpture, and painting where you see all there is to see at once, successive perception where art continues in time and changes with music, dance, and drama, and arts of space that are stationary like sculpture and painting and movable as in dance in theatre. These art forms represent aesthetic and creative inspiration by the artist for the observers. This chapter looks specifically at linking dance with poetry, visual arts, and sculpture.[1]

The intersection of dance and the visual arts merges the dance aesthetics through the inspiration of the choreographer with the influence on the costumes and set designs for dance production. Choreographers often collaborate with artists such as Martha Graham and Isamu Noguchi, Merce Cunningham and Robert Rauschenberg, and Pablo Picasso and the Ballets Russes. Pablo Picasso's abstract view exemplifies Modernism as seen in the costumes of the Ballet Russe. Great composers often become part of the team. The Graham/Noguchi collaboration included the music of Louis Horst and the powerful and strong collaboration of Cunningham and Rauschenberg often worked independently and with composer John Cage.

These are examples of very successful artistic collaborations based on artistic visions and trust.

CONCEPT: ART

Psychologist Rudolf Arnheim's work in visual perception views art through balance, shape, form, growth, space, light, color, movement, tension, and expression.[2] The underlying principles of dance and art overlap with the element of rhythm to create new artistic connections. While light, shape, space, and color are most visible in visual arts, the aspects of movement and rhythm create a beautiful intersection of dance and the visual arts.

VISUAL ARTS AND SCULPTURE

The prominence of dance in Ancient Greece is captured through examination of the art and artifacts of that society. We learn about Ancient Greek dance through the art of that era. The sculptures, bas reliefs, and images etched on objects depict dancing figures preserving the dance through the art. Studying those images reveals the visual form of dance movement captured by the Ancient artists, which is open for our interpretation. The literary works often describe the importance of dance in the daily lives in Ancient Greece contributing to the interpretation of the art.

Gilmanshin/Shutterstock.com

Ancient Greek sculpture of athlete

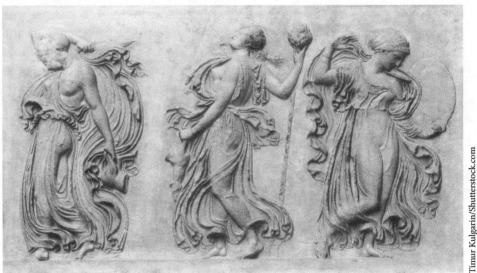

Timur Kulgarin/Shutterstock.com

Ancient Greek bas relief of dance

Greek dancers on a vase

Villi-Vonki/Shutterstock.com

There is no surprise to find that artists and sculptures depict the beauty of the human body through the visual arts and sculpture.

The beauty of the human anatomy may be viewed as a work of art. Whether looking at a scientific chart of the muscular anatomy, a painting of a dancer/dancer, or the sculpture of an athlete/dancer, the human body is featured in art throughout the centuries. Author Kenneth Clark writes of the nude anatomy: "What is the nude? It is an art form invented by the Greeks in the 5th century, just as opera is an art form invented in seventeenth century Italy."[3] Today, dancers are hired as models for art students trying to capture the beauty of the human anatomy. The dancer trains the body to near perfection for performance and provide a subject for the artist and sculptor as both form and function.

In the Romantic Era of art, dancers are featured in the work of some of the greatest artists and sculptures from Degas and Monet to Renoir and Rodin. The works of these artists have become iconic representations of ballet often replicated or commercialized in objects for dance enthusiasts. Edgar Degas is said to have had an obsession with classical ballet and his brilliant works are some of the most recognized paintings of dance. Degas captures the story behind the dancer, with many of his great works capturing the dancers in rehearsal and backstage.

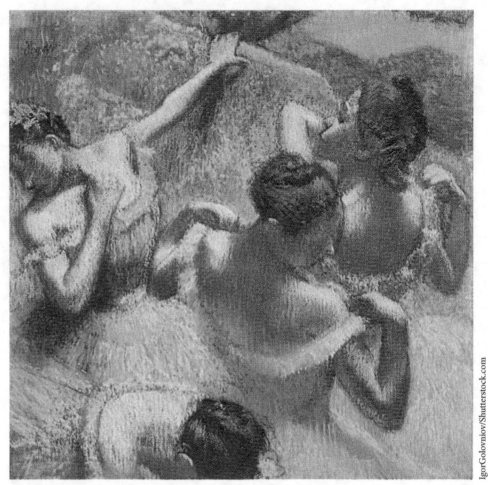

IgorGolovniov/Shutterstock.com

A Group of Dancers by Degas

Lars Poyansky/Shutterstock.com

Kandinsky

A work of art may inspire a choreographer as did Wassily Kandinsky to Martha Graham. Wassily Kandinsky exemplifies abstract art with his geometric forms, lines, and color. Upon viewing a Kandinsky painting, Martha Graham said, "I will dance like that," presumably seeing the rhythm in the lines and designs on Kandinsky's canvas.[4]

CREATIVITY

Creativity cannot be taught but is rather a process learned through experience and exposure and beginning through imagination. Some beliefs are of a divine inspiration or even at times accidental creative discovery. Looking at some of the characteristics of discovery and the psychological process may include times of becoming absorbed and isolated in their work. The creative process is not limited to the arts but is inclusive of the sciences, mathematics, technology, and other activities.

Poetry, as one of the Fine Arts, introduces a subtle link between art and mathematics. The mathematician uses symbols to form the abstract and the artist abstracts from reality, while both the mathematician and the artist seek structure. The numerical aspects of rhythm, be it visual or auditory, intrinsic or extrinsic, gives patterns and structure to both abstraction and reality.

The rhythm of poetry is embedded in the art. The words of a poet are presented with a rhythmic scheme, which emphasizes timing. For example, consider the methodical structure in poetry of the Haiku, Cinquain, or the Sonnet.

The simplicity of the Haiku is three lines with typically a syllable structure of 5-7-5 and no more than seventeen syllables. The Cinquain poem is composed of five lines with a specific pattern. These traditional poetic styles lend way to expressive interpretation for the dancer through simplicity, with a simple goal of capturing a single moment in few words.

The coupling of the Haiku or the Cinquain poetry with dance is often beautiful and a great start for young dancers and choreographers to begin expressing their emotion through movement by providing a stimulus for creative dance movement. Dance and poetry should not be a pantomime but rather a reflective, expressive statement of the meaning of those concise thoughts.

A classic example of the 5-7-5 syllable Haiku structure is "The Old Pond" by Matsuo Basho (1633-1694):

"The Old Pond"

An old silent pond
A frog jumps into the pond-
Splash! Silence again[5]

The Cinquain poem is composed of five lines with a specific pattern with a numeric scheme.

"November Night" a Cinquain by Adelaide Crapsey:
Listen…
With faint dry sound,
Like steps of passing ghosts,
The leaves, frost-crisp'd, break from the trees
And fall.[6]

A Sonnet is traditionally fourteen lines with a strict rhythmic scheme and often about love. The sonnets of Shakespeare are in fourteen lines each with ten syllables with an unstressed syllable followed by a stressed syllable and repeated five times.

A Shakespearean Sonnet scheme:

A
B
A
B
C
D
C
D
E
F
E
F
G
G

One of my favorite dance poems is "Dance In Your Blood":

Dance, when you are broken open
Dance, if you have torn the bandage off
Dance, in the middle of the right
Dance in your blood
Dance, when you are perfectly free.
By Rumi[7]

The rhythm of words and brush strokes may be measured with numbers to identify the patterns spoken, written, or visual. Yet, the link of mathematics and art is not to quantify the aesthetic but rather to find order in interpretation of the aesthetic image.

RHYTHM

The aspect of rhythm is powerful: auditory, visual, and kinesthetic. Perhaps, it is rhythm that links all the arts with dance. Rhythm grasps many concepts from visual to auditory, intrinsic and extrinsic, observational and kinesthetic; yet, there is no dispute that rhythm is identified with recognizable patterns. Thus, to see a rhythm in a painter's brush strokes, to hear the rhythm of musical notes, recite the meter of a poem, or for a dancer to feel the rhythm in their body, each case presents the recognition of repetitive patterns. Rhythm is often measured with temporal and spatial values. It is not unusual to think that we may also find art in mathematics and, no doubt, a mathematician finds mathematics as art. A link of mathematics and art is not intended to quantify the aesthetic but rather to find order in interpretation of the aesthetic image.

Mathematics may be the "sensuous logic" behind the art. In reference to art and sculpture of the nude anatomy, Clark makes reference to the body from a Euclidean diagram of energy to Degas' representation of movement[8] and the drapery of clothing to depict movement in athletes and dancers. Chapter 5 looks at costumes, lighting, and set design in dance production and dance on screen.

THOUGHT EXERCISES FOR CHAPTER 4

- Select a painting or sculpture that inspires you to dance.
- Choose an artist, musician, and a choreographer for a hypothetical collaboration.
- Identify a modern collaboration of artists in Popular Culture.
- Find a poem that inspires you to dance.
- Can you find mathematics in movement?

MUSINGS

Dance, as an art form, is a collaborative event. The whole is greater than a mere sum of the parts. Keep in mind that there is no right or wrong with art and creativity has no boundaries. Finding and feeling both intrinsic and extrinsic rhythms aid in seeing the art and becoming artists. Everyone has an ability to create their own art. Mathematics may be the "sensuous logic" relating to philosophy, the arts, music, dance and poetry.

ENDNOTES

1. Richard Kraus, Sarah Chapman Hilsendyer, and Brenda Dixon, *History of the Dance in Art and Education* (Englewood Cliffs, NJ: Prentice Hall, 1991), 15.
2. Rudolf Arnheim, *Art and Visual Perception: A Psychology of the Creative Eye University of California Press* (Berkeley, Los Angeles and London, 1971).
3. Kenneth Clark, *The Nude: A Study of the Ideal Form* (Garden City, NJ: Doubleday Anchor Books, Inc., 1956), 25.
4. Neil Baldwin on the Shared Aesthetic Visions of Modern Dance and Modern Art Literary Hub, accessed October 25, 2022, lithub.com.
5. www.readpoetry.com presented by Andrew McMeel
6. Adelaide Crapsey, "28 Cinquain from Crapsey's Verse," (1922), 31.
7. Roger Housden, Editor, *Dancing With Joy – 99 Poems,* Harmony Books, a Division of Random House, 2007, p.103.
8. Clark, *The Nude*, p. 242.

Dance Production on Stage and Screen

> I wanted to create a new form of art, an art completely irrelevant to the usual theories, an art giving to the soul and the senses at the same time complete delight, where reality and dream, light and sound, movement and rhythm form an exciting unity.
> —Loie Fuller

Dance performances often incorporate the fundamental production elements of costumes, lighting, and set design in a collaborative effort with theatrical arts. This chapter looks at those production elements that enhance the dance for the audience, the choreographer, and the dancer on our interdisciplinary journey. Following a discussion of basic dance production, dance expands on the screen in film and television through the intersection of dance on the camera.

CONCEPT: DANCE PRODUCTION

A dance production usually is performed on a stage with music, costumes, and lighting, which may be either indoors or outdoors. The elements of costumes, props, sets, scenery, multimedia, and other technical elements add to the aspects of production. Keep in mind that a dance performance may be performed almost anywhere without these production elements, although some form of music accompanies the dance.

COSTUMES

The elements of line, shape, volume, value, texture, and color are vital to costume design and the dance performance. Most importantly, the costume must move

with the dancer becoming a part of the dance and tailored to fit the dancer in motion. The shape defines the geometry or proportion of the costume, which may be suited for specific choreographic or visual points. For example, the proportion of the short ballet tutu is designed to highlight the legs of the ballerina by being fuller at the hipline, suggesting an elongation of the lower limbs. The lightness or darkness of color refers to the value of the fabric and is often created with multi-colored threads woven into the fabric.

Repetition and variety, emphasis and rhythm, scale and proportion, unity and balance are simple principles of costume design. Repeating a color combination, fabric, or style accentuates a point and grabs the eye of the viewer, while variety depicts a factor of change or transition. The simplicity of repetition and variety reinforces a visual rhythm for the audience. Costumes help to tell a story but should not disguise or hinder the dance movements. The proportion and scale of the costume design should not overpower the dance or distract from the movement. The genre and style of dance often influence the costume design by depicting a theme, era, or specific dance style.

The visual elements of dance costumes attend to color, fabric, and style. The colorful dresses of the Ballet Folklorico capture the excitement and joy of the performance, the chiffon fabric of Middle Eastern Belly Dances shapes and flows with the dancers' body, and the color palette sets the stage for the distinct looks for the Sharks and Jets in the iconic Dance at the Gym in *West Side Story*.

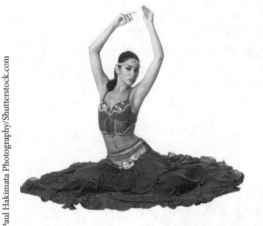

Middle eastern dancer

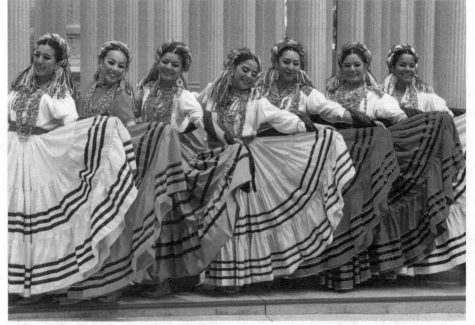

Ballet Folklorico

While the costumes of the 1961 *West Side Story* may resemble today's fashion with the timeless look of jeans, leather jackets, and T-shirts, costume designer Paul Tazwell uses color to reinforce the rivalry theme in the 2021 *West Side Story* film. Tazwell uses cool colors of blue, teal, and grey for the Jets with the Sharks in red, yellow, orange, and brown yielding a more tropical image. Tazwell tailors the dresses of the Jets women with what has been called a "tricky costume geometry" that opens for dance movements.[1] Tazwell's use of color pops throughout the dynamic street scene of "America." The women wear vibrant colors with ruffles and slips that become a part of the dance, which accentuates the importance of fabric and color to enhance the dance in the 2021 *West Side Story* film.[2]

SET DESIGN

The aspect of set design incorporates an artistic element often by connecting both the costumes and set design. Consider the works of Noguchi and Graham, Rauschenberg and Cunningham, or Picasso and the Ballets Russes that carry the artists' visions through the costumes and set design. Clearly, costumes and sets reinforce the theme and enhances a choreographic vision.

When a traditional theme takes a twist in the setting, the costumes and set design set the mood and era for the new version. In choreographer Mark Morris' *Hard Nut*, the traditional *Nutcracker* ballet found a new contemporary look emphasized with costumes and set design.[3]

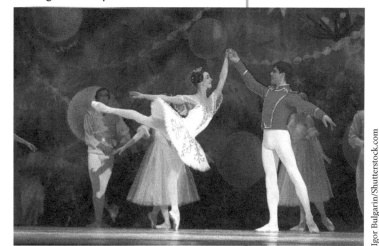

Classical Ballet Nutcracker

Igor Bulgarin/Shutterstock.com

Similarly, the revision of *Swan Lake* by choreographer Matthew Bourne has a gender twist and his costume design illustrates the point with his "dancing swans" with casting, costumes, and set design. Perhaps, Bourne's *Swan Lake* is even more relevant today.[4]

Costumes add to the story whether traditional or with a twist. Fashion designers work with a choreographer to design the costumes; for example, CoCo Chanel working for Serge Diaghilev and the Ballets Russes. The works of visual artists, such as Pablo Picasso, Mark Chagall, Henri Matisee, and Robert Rauschenberg, are part of dance collaborations.

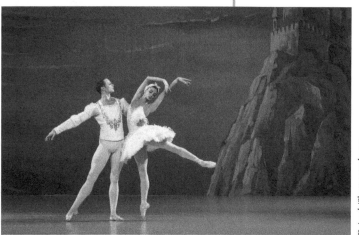

Traditional Swan Lake

Dziurek/Shutterstock.com

LIGHTING DESIGN

Whether the dance is on stage, in a gymnasium, or in a studio, indoors or out-doors, lighting is essential. The audience needs to see the movement. The art and science of lighting design began with the simplicity of candlelight and torchlight to the natural sunlight from the ancient outdoor amphitheaters to the sophisticat-ed stages of today. Stage lighting design enhances the dance and becomes essential to the dance performance: you must be able to see the dancers.

The purpose of stage lighting is simply for visibility, naturalism, composition, and mood. Lighting provides visibility, establishes time and place, creates a mood, reinforces style, provides focus and composition, and establishes a visual rhythm. The qualities of light refer to the intensity or brightness of the beams, adaptations or dimming, avoiding visual fatigue for the audience from too much or too lit-tle lighting. No doubt,lighting enhances visual perception, creating intensity or mood, and focuses the action by distribution of the light.

Lighting accentuates dance by focusing the attention on certain movements to highlight the human form and gestures of the dancers. Emotions and moods may be enhanced with the simplicity of the lighting beams, while more elaborate light-ing designs integrate into the choreography through visual rhythms. For example, lighting highlights the primary focus of performance with the secondary focus in the darker lighting area. In dance, the lighting must add to the dance without overtaking the bodies in motion.

The choreographer and the lighting designer collaborate in the dance production with a joint artistic vision. In lighting, color adds to the performance by creating

GoBo lighting effects

Backlight Effects

the mood from highlighting dancers in the forefront to using back-light for more drama and emotion or a spotlight that may follow the dancer. Special effects are created with projections of gobos to produce images like moonlight, stars, lighting, water, or fire.

On stage, dance often works with backlight and side booms and sidelight often imitating the beauty of nature. Martha Graham worked with lighting designer Jean Rosenthal mastering the drama of backlight, side lights, and the three-tier side booms to add to the beauty of the dance experience.[5] Adolphe Appia, an-other twentieth-century lighting designer, worked with modern dance pioneer Isadora Duncan to integrate dance and lighting by "painting with light."[6] In the mid-1920s, Stanley McCandless' use of front lights, backlights, downlights, and sidelights was me-thodical in creating the grid for stage lighting.[7] The McCandless Method works with a "cross-spotting" technique that works with bodies in motion on stage via the grid of six lighting areas: three upstage and three downstage.

Each area is 8 to 10 feet in diameter with two spots per area (one spot warm and one spot cool). McCandless uses warm light as the key ingredient and the cool light as the fill, working together to enhance the moods and emotions on stage. The spots are hung 45 degrees above the edge and 45 degrees off center of the front lights with color-toning strip lights above the dancers.[8]

Side Booms

DANCE ON SCREEN

Projecting dance onto the screen broadens the aesthetic dimension of dance for the audience for the choreographer. The camera expands the dance experience from a single stage, theatre, and audience to a global audience whether on film, television, video, livestream, or social media.

Dance on screen is a creative endeavor not intended to replace live performance but rather offers a unique aesthetic and a greater collaboration of artists. The art of the camera expands the dance experience with many editing techniques such as: splicing, slow motion, fast motions, and reverse angles. In addition, filming dance offers a straightforward recording of the choreography for notation and copyrights.

Currently, social media provides an explosive global platform for dance of all styles, for all ages, and abilities. Filmmakers embrace dance throughout the decades of the twentieth century. Prior to the era of the 1940s dance musicals of Hollywood, dance lifted America through the "roaring 20s," the Great Depression, and World War II. From the Nicholas Brothers' breathtaking steps in Stormy Weather, Gene Kelly "Singin in the Rain," and Fred Astaire's revolutionary "ceiling dance," the camera adds to the dance experience. The high-energy, vibrant, athletic tap dancing of the Nicholas Brothers keeps the audience riveted into the film with the extraordinary camera techniques. When Gene Kelly danced in the rain on the movie set, the rain was made more visible with the addition of milk for better camera overage. It was the brilliant camera work that seamlessly had Fred Astaire dancing up the walls and not the ceiling.

Some of the most exciting work in Hollywood came from the genius of choreographer and director Busby Berkeley. Berkeley is known as a film pioneer and designed his elaborate choreography for the camera and not really for the dancer. He is best known for his kaleidoscope effect of using bodies in motion to keep the eye of the observer focused on the film. To me, his genius lies in the precision, timing, and mathematical schemes in his choreography clearly illustrated in *Footlight Parade* of 1933 and the human waterfall. Berkeley's genius gave a visual rhythm to match the elaborate dance choreography of numbers.[9]

The magic of the camera takes dance to another dimension that creates illusionary dance technique. Often lead actors are not trained dancers and the camera displays isolated movements and presents them as dancers. The camera focuses the attention of the audience on close-ups and perfectly angled film shots of these actors actually dancing to make their performances quite technically believable. The audience seldom sees a full shot of the dancers and the camera focuses the attention on the facial expressions, arm movements, and close-ups. Again, the camera plays an important part of the making of this dance film. The lead actor does dance her scenes, although the camera plays an intricate role in making her

dance look far more spectacular. Film editing allows for the use of dance doubles to perform the dance numbers for the lead actors, as in the 1980s film *Flashdance*.

Iconic dance film *West Side Story* (1961), choreographed by Jerome Robbins, features dancers really dancing with some of the best choreography on film. Three dance numbers stand out as being spectacular both on stage and even better on the screen: The Dance in the Gym, America, and Cool. The camera follows the movement of the dancers rather than leading the focus of the dance in Dance in the Gym. The definitive lines drawn between the Sharks and the Jets are seen with their dance movements. America, danced on the rooftop (1961 film), is an exciting dialogue of movement between the men and women of the Sharks. The rooftop setting and camera work become a part of this exciting dance where rhythm is visualized with the movement. Cool is performed by the Jets in a garage where camera and dance unite. The excitement and energy build with both the lighting and camera work. *West Side Story* (film 2021) restages these three iconic dance numbers in different setting, yet telling the same story. No dance doubles are in *West Side Story*. All scenes were rehearsed and danced by the dancers.

The techniques and technology of today were preempted by earlier work in movement, costumes, and lighting. Early modern dancer, Loie Fuller pioneered the use of both costumes and lighting in her dances of the early 20th century. Her Serpentine Dance continues to be recreated by dancers today. In her own words, fuller created a new form of art merging light, sound, movement and rhythm. The camera expands the dance offering greater creative possibilities from recording and notation, to editing and illusion. In Chapter 6, the camera merges dance and photography to capture motion in a single-frame image. The union of dance, photography, and architecture further extends dance opportunities through interdisciplinary, creative, art experiences.

THOUGHT EXERCISES FOR CHAPTER 5

- How does lighting focus your attention in everyday life?
- Describe your favorite clothing for dance.
- Enjoy the differences in the settings for the dance "America" from *West Side Story* 2021 and 1961. Do you have a preference?
- Which setting and costumes capture the essence of the dance in "Cool" from *West Side Story* 2021 and 1961.
- Create your worn version of Swan Lake by selecting a choreographer, dance style, costumes, stage design, music style, and artists. This is intended to be a hypothetical collaboration of artists (living or dead) in mixing various styles.

MUSINGS

What we wear often prepares us for a certain activity. In my beginning dance classes, the instruction given to my students is to wear something that makes them feel like dancing. Certain dance styles identify with specific attire from ballet slippers and tutus to hip-hop baggies and boots. The clothing worn prepares and frees the dancer for movement and should accentuate the choreography and dance. Dance styles often have distinct dance costumes; from the tutu of classical ballet to the free-form styles of hip-hop dancers. No doubt, clothing and fashion are a part of the dance culture.

A suggested preference in dance production is to keep the stage uncluttered and wide open for dance. The use of technology, multimedia, and overhead screens is a great way to keep the stage open for movement, yet establish a mood or setting. Lighting needs to enhance and focus the attention of the audience on the movement rather than becoming a distraction.

ENDNOTES

1. "Dressing 'West Side Story' for a new era" by Valli Herman *Los Angeles Times,* December 29, 2021.
2. Anne Levin interview, *The Observer*, March 10, 2022.
3. Joan Acocella, "The Genius of the 'Hard Nut,'" *The New Yorker,* December 1, 2016.
4. Lewis Segal, "Review Why Matthew Bourne's Male 'Swan Lake' Is Still Radical and Relevant 24 Years Later," *Los Angeles Times*, December 6, 2019.
5. Veronica Flesher, "Jean Rosenthal: Pioneering Lighting Designer," *Forgotten History*, August 3, 2022, www.shesources.co.
6. Mika Panagou, Nikos Kamtsis, and Sofia Gourgoulianni, "The Impact of New Technologies on Theatre & Costume", *International Journal of Science and Academic Research* Vol. 02, Issue 10, pp. 3122–3133, October 2021.
7. "McCandless Method for Stage Lighting," *Illuminated Integration*, June 3, 2022.
8. Tom Skeleton (courtesy of *Dance Magazine*) first published November 1955; *Handbook of Dance Stage Craft* (Duluth: University of Minnesota), www.umn.edu.
9. Richard Brady, "Busby Berkeley Personalized Beauty," *The New Yorker*, December 7, 2016.

Dance Photography and Architecture

> The dance is the mother of the arts, Music and poetry exist in time; painting and architecture in space. But the dance lives at once in time and space.
> —Curt Sachs, German musicologist

A photograph captures a moment in time and space with a variety of possibilities for the artistic union of the camera and the dancer. One feature of great dance photography is to capture the essence and image of motion in a single still frame. While this may sound contradictory, an image of motion can be depicted in a single still frame. Certain elements of costuming and lighting accentuate the movement of a dancer with the lens of the camera. The camera takes dance from beyond the stage and into, literally, into a world full of locations, and inspiring site-specific performances. Architecture offers dance a vast array of venues and locations for thematic work from buildings, landscapes, fountains, and nature. This chapter looks at the camera as a tool to record human movement and the union of photography with architecture uniting dance with inanimate objects on location in beautiful settings.

CONCEPT: TIME AND SPACE

A challenge for dance photography is to depict motion in that single-frame photo of a particular moment in time and space with that moment vanishing. Ancient Greek philosopher Zeno of Elea's Paradox of the Arrow questions elements of time and space.

Aristotle explains from Zeno's Paradox of the Arrow…. "assumption that time is composed of moments…"[1] that a moving arrow must occupy a space equivalent to itself during any moment. Biomechanics utilizes frame by frame analysis to study movement patterns and sequences. While a photograph captures a moment in time in a single frame, the challenge for dance photography is to depict motion in that single frame remembering that each frame is a moment in time and space similar to Zeno's arrow.

The beauty of frame-by-frame shots is the ability to capture the movements in singular moments of time and space. The "burst" option on the camera creates a video of a movement sequence enabling an option for a frame-by-frame movement analysis. This method of movement analysis is an excellent teaching tool for the dancer and the choreographer. Keep in mind, the "dance" is happening in between positions in space as the dancers find their way from point A to point B. The dance is created by linking those points in space as the dancer travels in a continuous path of movement.

Dancer in action

DANCE PHOTOGRAPHY

Dance companies hire skilled dance photographers to record the dance movement in a single-frame still images, often for promotion and advertising of dance events. Truly, dance photographs are a work of art for both the dancer and the photographer. Many amateur dance photographers emerged from the restrictions of the COVID pandemic. Somehow, isolation, camera phones, and social media resulted in many spectacular movement photographs often discovered as "acci-

dental" art. The person behind the camera may not be setting out for a particular photo but on the way stumbled onto a great action shot. That is, sometimes the action is captured by finding a transitional moment. One thing is for sure—a great dance photograph is clearly distinguished from a posed or portrait shot, with "action" being the key word. This difference is illustrated in the two photos shown below.

Some helpful hints for dance photography may assist in finding those great shots; for example, determining the subject, selecting the location, determining the number of dancers, and choosing the patterns of movement. In addition, visit the location and observe the setting from various angles and points of view. The way the camera lens sees the dance is part of the creative process, as demonstrated by choreographer and film director Busby Berkeley. Berkeley used the camera as a tool to enhance spectacular views of his choreography from overhead shots to underwater photography in the early days of Hollywood filmmaking.

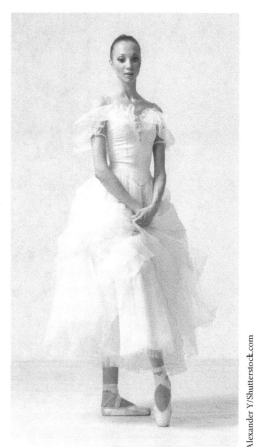

Alexander Y/Shutterstock.com

Posed dancer

Stasia04/Shutterstock.com

Dancer photographed from above

Stasia04/Shutterstock.com

Dancer photographed from below

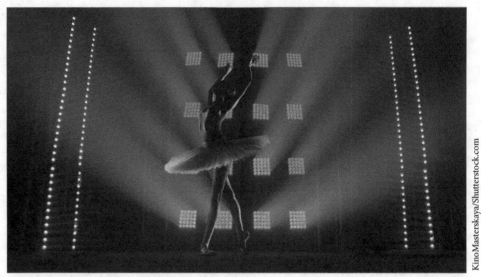

Dancer with elaborate stage lighting

Dancer in natural lighting

The aspect of lighting is essential for the photographer. Consider whether you are working with artificial or natural lighting. Natural lighting must take environmental factors into consideration such as time of day and season of the year. Indoor lighting is more predictable and reliable, but avoid any harsh and overly artificial effects. Costumes for the dancers are as important in dance photography as they are on the stage in creating a mood and theme. The costumes should accentuate the dancer's body and enhance the movement, as with only a single-frame shot, all elements need to work together in creating the motion. Consider the background and avoid any visual distractions that would take the views eye away from the dance.

ARCHITECTURE AND DANCE

Dance and architecture may appear an unlikely artistic combination. The structure of an architectural site and the rhythm of human motion create an interdisciplinary experience for both the artists and the audiences. Whether dancers are juxtaposed around a building or performing in site-specific locations, architecture and dance combine to spark the creative imagination.

Site-specific work moves dance outside of the theater and off the stage to include places like buildings, landscapes, fountains, stairways, and stairwells. Legendary dance critic Edwin Denby distinguishes between what is happening on the stage and what it is that you see.[2] Denby notices the familiarity of movement on the streets of New York City and the "walk of New Yorkers." In his classic book, *Dancers, Buildings, and People in the Street*, Denby finds daily life full of things to see:

Karelian/Shutterstock.com

Dancers and architecture juxtaposition

people moving, objects, shapes, and architecture, with varying environmental elements. Thus, everyday life becomes an exciting venue for dance. The observer's point of view determines whether you are "seeing daily life" or "seeing art."[3]

The specificity may be inclusive of unique settings like churches, airports, and railroad stations, just to name a few. Our daily environments are full of wonderful locations, just look out your window or walk out your door to find that perfect dance setting. The specific setting may have a particular meaning (i.e., church, library, classroom), with the dance element adding the feature of people to the special setting.

Another aspect is to observe and re-create the flow or pattern of people in that particular setting. In 2011, journalist Alastair Macaulay observed the throngs of people moving through New York City's Grand Central Station. Everyday life and setting are the things we dance about, which was confirmed by choreographer Merce Cunningham and author Edwin Denby.[4] Bodies in motion in endless locations around the world provide themes and actions for dance. Dancers moving through everyday spaces provide a look at alternative patterns for movement in architectural design.

SITE-SPECIFIC PERFORMANCES

Ordinary spaces may be brought alive for an audience through dance. For example, a site-specific location may have a story to tell, and the audience may feel a special connection to a place where the dance is being performed.[5] The post-modern work of choreographers Pina Bausch, Trish Brown, Meredith Monk present their works outside of the theatres from the streets of New York to works in nature on hillsides and blowing with the winds. Choreographer Heidi Duckler continues the trend on location in Southern California and beyond. Interesting locations surround us for site-specific works whether in live performance, in photography, or on video or film.

The closing of dance studios and theaters in the COVID pandemic did not stop the dance. Actually, dance grew beyond the boundaries of traditional rehearsal and performance spaces by expanding the work of dance into new locations and creating new opportunities for dancers and non-dancers.

Taking dance off the stage and onto location expands the venues and themes for dance out of the studios and theaters and into the city streets, the country side, and often unlikely locations which continues to reshape the platform of dance performances. The results have been magnificent, even with dancers and choreographers working in their own confines and discovering new and exciting venues to expand their art.

A wonderful example of site-specific performance came at the 2021 inauguration of President Joe Biden. Legendary choreographer Kenny Ortega created a brilliant montage on the video *Dance Across America*. The dancers auditioned short segments of dance performed on location around the country. *Dance Across America* illustrates the enormous span of dance, as demonstrated through the diversity of the performers and locations outside the theater and the studio. Everyone can dance their own dance and we can dance almost anywhere including beyond the traditional boundaries.

SPACE, PLACE, AND PEOPLE

Site-specific work merges dance, photography, and architecture with those simple Denby's concepts of dance, buildings, and people in the streets. While we may figuratively find a dance in nature, it is human movement and dance that remain the focus. Thus, seeing dance in the movement of people is everywhere and simply a matter of perception. Whether you see movement as pedestrian or artistic is a matter of taste and judgment.

The options for dance "space" are everywhere and anywhere. Look around, and sometimes the most obscure locations become the most interesting spaces to explore. Dance may add beauty to dismal surroundings and even the junkyard of discarded objects. Identifying a particular location or architecture site may be the focus of dance exploration and artistic creative. Consider an abandoned building, a beautiful concert hall, the confines of a cathedral, a skyscraper, and the places are endless. As Denby reminds us to "see" the art. Finding a location or special place for dance is a beginning for site-specific work in either photography or performance. Bringing the space and place to life comes with movement. The dancers are the people in the environment, from dancers to nondancers moving through space and time.

THOUGHT EXERCISES FOR CHAPTER 6

- Work with a partner to find action through the camera lens and submit six photos.
- In small groups, choose various locations on campus for a photo shoot and take a walk through.
- Submit several action shots from the campus locations.
- Image a walking tour of dance and architecture in your hometown.
- Create a hypothetical site-specific performance: location, dance style, music, and costumes.

MUSINGS

Architecture is fixed in time and space, while dance moves and vanishes from moment to moment. Each place is occurring in a new time frame. The art of photography becomes the perfect tool to merge the art forms of dance and architecture. Making dance move in a single frame is often a challenge of dance photography, just as bringing buildings to life is a challenge for architecture. Just as the camera lens focuses the eye of the audience to specific movements, so does the dance highlights lines and designs of architecture. Whether dancers are juxtaposed to buildings and sites or moving through specific locations, the audience sees dance and architecture in a fresh new way. Finally, site-specific performances broaden the scope of performance venues and enlighten the audience.

ENDNOTES

1. Stanford Encyclopedia of Philosophy. 3.3, plato.stanford.edu
2. Edwin Denby, *Dancers, Buildings and People in the Streets* (New York: Curtis Books, 1965), 150.
3. Ibid., p. 157.
4. Alastair Macaulay, "The Fluid Human Dance That Is Grand Central Station," *New York Times*, August 31, 2011.
5. Melanie Kloetzel, "Site-Specific Dance in a Corporate Landscape," *New Theatre Quarterly*, May 13, 2010, 135.

PART III
DANCE COLLABORATIONS

Kinetic Art and the Bauhaus School of Design

7

...the totality is not, as it were, a mere heap,
but the whole is something besides the parts.
—Aristotle, *Metaphysics*, translated by W.D. Ross

As our journey continues, a look at kinetic art and the Bauhaus School of Design illustrate benefits of collaboration through interdisciplinary work. Let us remember that the design process, whether in dance, architecture, or product design, brings together information into new combinations by the cross-referencing and sharing of information often resulting in new creative discoveries. Combinations, cross-referencing, and collaborations are key elements.

CONCEPT: FORM FOLLOWS FUNCTION

"Form follows function" is a slogan coined by industrial designer Louis Sullivan. Sullivan's reference to the design of industrial objects to focus on both the form and function of often utilitarian objects. The creative process of Industrial design combines the artistic impressions of the individual with the production of utilitarian objects. Utilitarian objects may be aesthetically pleasing, as well as being functionally sound.

Just as utilitarian objects join these concepts of form and function, so does the human body in both dance and sport. The biomechanics of human movement supports the process of applying shape and form of the skeletal and muscular systems to the purpose and technique of the intended movement function. In sport, the

International Olympic Committee motto promotes "Faster, Higher, Stronger—Together" for the athlete, while in dance the aesthetic and flow of the movement are additional factors. Form does follow function for the human body whether in dance or sport.

The structure of the human body applies the slogan of "form follows function" in activities of everyday life, sport, and dance. The human body will adapt to certain activities and repetitive movement. Wolff's law is a reminder about the human capability for design adaption in movement. German anatomist and surgeon suggested, "The shape of a bone is determined only by static loading and the form and structure of a bone constantly adapts to mechanical landing."[1] Embryologist Wilhelm Roux worked with Wolff and established Roux's law with a slight adaption that includes "cellular regulation and function adaptation to stressors."[2] Form does follow function has anatomical implications for human movement.

KINETIC ART

Kinetic art, as the name implies, works in the realm of motion and actual movement of objects as art using mechanized systems to move objects in space. Kinetic art includes two- and three-dimensional works in actual movement, which includes machines, mobiles, projections, and works in virtual movement that rely on the spectator's eye responding to a physical stimulus.[3]

Fernand Léger was known for his graphic mobility and use of machines, as early as 1917. Leger designed sets for two ballets: *La Patinoire* in 1921 and *La Fin de Monde* in 1920, and cinema *Ballet Mécanique* from 1923 to 1924.[4] The motions of the mechanical art and human movement together bring dance to another aesthetic dimension creating a greater experience for the audience.

Kinetic artists distinguish the object and the movement as separate parts of the work of art. Len Lye established an important distinction between the shape of motion and the shape of the object. As critic Katharine Kuh, speaking of Lye, states, "He literally choreographs his motorized sculpture, depending on automatic programming that has been pre-timed and coordinated with impeccable precision to achieve innumerable vibrating, rotating, configurations."[5]

The strongest influence in the development of kinetic art comes from the science and technological sphere. The idea of the wheel, fireworks, fountains, and robots are examples of technological influences. The kinetic artist begins working in a new medium, although various artistic traits include craftsmanship, conceptual and visual thinking, and design.

Artist László Moholy-Nagy brought his constructivist ideas of balance and form to the Bauhaus school. He taught a workshop in metals and was considered a master of form.[6] At the Bauhaus, he experimented on plastic and aluminum with

his paintings and used lighting on the objects. Moholy-Nagy's kinetic sculpture of an electromechanical device with lighting projected on the moving parts.[7] This artistic exploration is one example of the creative discovery at the Bauhaus.

BAUHAUS SCHOOL OF DESIGN

In twentieth century Germany, the faculty and students of the Bauhaus movement worked together to explore the aesthetic aspects of product design, architecture, art, and dance in collaborative work with the technology of the times.

Architect and founder of the Bauhaus School, Walter Gropius sought unity and not isolation among the artist and craftsmen. The idea was to prepare students for work with both craft and industry in a combined effort with art. A synthesis of abstract modern art, new industrial design, and new world architecture through a visual display of aesthetic products and techniques was demonstrated at the school.

Bauhaus artist and choreographer, Oskar Schlemmer appears to have dehumanized his dancers combining his rather outlandish costumes with almost mechanical movements. Through costume design and minimalistic movement, Schlemmer's dancers appeared to be robotic. Schlemmer's avant-garde *Triadic Ballet* is a masterpiece of shape, color, and three-dimensional space[8] and a collaboration between Schlemmer and composer Paul Hindemith. In his own words, Schlemmer describes his work as "artistic metaphysical mathematics." *Triadic Ballet* is based on threes: three dancers, three acts, twelve choreographies, and eighteen costumes. The color scheme was simple with act 1 in yellow, act 2 in pink, and act 3 in black. Schlemmer's avant-garde influence is often overlooked in the world of dance.

Schlemmer's costumes for the *Triadic Ballet* were considered to be mechanical and geometric-looking, almost disguising the human form. Clearly, this work of the early twentieth century somehow represents a human and machine dichotomy. This short piece of avant-garde dance by Schlemmer has inspired many, from Fritz Lang's film *Metropolis* in 1927 to David Bowie.[9]

While the curriculum of the Bauhaus cannot be duplicated, the basic principles that guided the creative thinking experiments and the collaborative experimentation of students and faculty provide vivid examples of the integration and interdependence of art and technology.

ALWIN NIKOLAIS

The works of American choreographer Alwin Nikolais were considered avant-garde in the mid-twentieth century. His dancers appeared to move in almost

mechanized style while exploring elements of technology new to that era. Nikolais used props, costumes, and lighting in innovative ways exploring the texture and qualities of movement and expanding the form of the dance into space.

Nikolais denied any connections with the Bauhaus, although his work with color, shape, motion, design, and dimension bear a Schlemmer flavor. Nikolais stated,

> Some stimulus coming from somewhere triggers a motional schemata. You just start working and things happen. You don't know why you do what you do until suddenly you see it.[10]

Alwin Nikolais created his own art of lights, motions, and sound that impacted the world of modern dance. Nikolai's work was my first exposure to modern dance in the 1960's. Perhaps, that early influence of Nikolai led to my later work in developing Robot Choreography in the 1980's.

Dance as the vehicle on our interdisciplinary journey keeps our focus on movement and aesthetics, as our cross-references, combinations, and collaborations expand. The expansion of our thinking and the addition of new ideas and elements demonstrate that the whole is greater than a mere sum of the parts.

THOUGHT EXERCISES FOR CHAPTER 7

- Describe the aesthetic design of an object that you use everyday.
- Find an example of "form follows function" in both dance and sport.
- Redesign an everyday object for an aesthetic appeal but maintain the functionality.
- How might Alwin Nikolais work with today's music and dance culture?
- Create a multimedia experience for dance: choose a dance style, artist, and theme.

MUSINGS

My work in the development of robot choreography in the 1980s was considered a pioneering new field at that time. A curiosity for an historical and theoretical foundation for the ideas of dancing robots led me to the discovery of the works of the Bauhaus school of design and kinetic art. A simple and constant reminder to my dancers and choreographers is that what is aesthetically pleasing is not always anatomically correct. Form does follow function in human movement. The similarities between kinetic art and the choreography of robots expand the artistic perspective of art in motion.

ENDNOTES

1. Gayanne Grossman, *Dance Science* (Princeton Book Company Publishers, 2015), 19, www.dancehorizons.com.
2. Ibid.
3. Frank Popper, *Origins and Development of Kinetic Art* (New York: New York Graphic Society, 1968), 105.
4. Ibid., p. 90.
5. Ibid., p. 105.
6. Michael Robinson, *Bauhaus Masterworks* (London, England: Flame Tree Publishers, 2017), 33.
7. Ibid.
8. Nadine Waldman, "Modernization in Motion: Bauhaus' Triadic Ballet," *Daily Art Magazine*, December 9, 2022, www.dailyartmagazine.com.
9. Ibid.
10. Ruth E. Grayert, "Nikolais and the Bauhaus," *Bearnstow Journal,* Vol. 1 (2000).

Dance and Technology

...technology alone is not enough – it's technology married with liberal arts, married with the humanities, that yields us the result that makes our hearts sing.
—Steve Jobs, American entrepreneur

The technological reference of the Bauhaus School reflects the era of the early 20th century and the industrial revolution while in the 21th-century technology continues to evolve rapidly. A guiding principle of the Bauhaus was, "… artistic design is neither an intellectual nor a material affair, but simply an integral part of the stuff of life."[1] We must not lose sight of both the form and the function of the objects in our lives. This chapter looks at the merging of dance and technology with examples from robotics and performance capture, to mixed reality.

Science often relates to art in terms of new materials. Technology aids on the development of advanced products often used in the art, although artist may have little to do with the technology development. There was once a "technological imperative" stating, "The Force to implement new technology because it is possible to do so. Man cannot, in the case of an imperative, decide not to implement the new technology becasue it must and will be done."[2] Throughout the past decades, many uses and discoveries of computers and robots demonstrates this technological imperative. The pandemic of 2021 posed a challenge to dance training and performance. The traditional art and dance venues were closed and dance expanded through virtual environments to expand performance opportunities and enlarge the audience through the merging of dance and technology. Dancers embraced the technology creativity in both training and performance with even robots commonly joining the dance floor.

CONCEPT: ROBOT CHOREOGRAPHY

The idea of "dancing robots' was rather unique in the early 1980"s; however, Robot Choreography was the topic of my doctoral dissertation at Stanford University. In the 1980's a fundamental question driving my curiosity was whether an industrial robotic arm could move gracefully and working to develop this human machine interaction was extremely exciting.

A collaboration united my dance experience with the knowledge from a team of mechanical engineers and designers at Stanford. The engineers and designers were not dancers, while I was not a roboticist. We unite through the technology and development Robot Choreography. Our work included the application of this new artistic venture with rehabilitative robotics in a hospital setting. The industrial robotic arm was being designed to serve as an assistive device for patients with high-level spinal cord injury with a focus on user acceptance of the machine.[3] My research examined user acceptance of a robotic arm; that is, whether patients would be more likely to use the robot when the robot moved more gracefully.

The development of Robot Choreography established a new vehicle for creative expression. The invention and development of the new technology is a product of human work; thus, the creative applications of the technology may also be considered a product of human expression. Robot Choreography, like computer music and programmable sculptures, uses technology for aesthetic goals to provide a new vehicle for combining art, science, and engineering. In the "training" of robot dancers via software or in "playing" robots as kinesthetic-visual instruments, the choreographer achieves new freedom and expression. In defining for a robot, the parameters of "graceful" movement, we learn much about our own perceptual process. And in enjoying the resultant performance, the audience, mapping its own awareness onto the nonhuman expression of the robot, experiences a synthesis of sight, sound, and feeling perhaps not previously available to our species.[4]

Robot Choreography demonstrates an artistic-scientific combination that blends various talents and tools into a unitary piece: sculpture of movements in space, the musicality to rhythmic response in time, and the expression of symbolic gesture of dance. A dancing robot is possible as a creative expression of both artist and scientist as perceived by the audience through the communicative language expressed in the work of art. In Robot Choreography, the purpose is not to develop a creative machine but rather a machine used as an expression of creativity.

The process of Robot Choreography appears to be similar to that of the human counterpart: a theme or idea is translated into a spatiotemporal event sequence (structure, postures, movements) and then melded with auditory and visual harmonies (lighting and live or recorded music). The intention is to excite the viewer's neural pathways representing reflex, conditioning, memory, and conscious awareness, to produce a new feeling or experience not otherwise communicable.

In this sense, choreography, like other arts forms, is projective: the observer's experience and is intensely creative, reflecting the ability to identify with the actions and attributes expressed in the dance.[5]

CHOREOGRAPHY

Choreography, the art of making dances, involves intellectual, artistic, and movement processes. Individually, choreographers work differently, often employing a variety of creative techniques. In my programming for robots, a dance often begins with a conceptualization of a theme or idea diagrammed in a sketchbook. In working with recorded music and live accompaniment, the movements and movement phrases were synchronized with musical phrases and programmed for the robot. Working from large gesture to small actions, the robot becomes a vehicle for expression in spatial and temporal sequence.[6]

The mechanical features of the staccato action of a robot are contrasted with what may be defined as "aesthetic maneuvers" which results in a robot moving gracefully. The aesthetic movements feature a more sustained effort in the actions, smoother transitions from point to point, curved lines replacing many of the straight and short angular motions and a varied sequence in the timing of movement phrases to break up the constant speed characteristics in the mechanical patterns of robot motion. The aesthetic maneuvers explore the related movement elements of the action quality, flow, shape, and timing in various movement phrases.

The elements of shape, space, time, and force are used in dance exploration, and these movement elements can be used in both artistic and scientific aspects of robot tasks. The position and actual movement of the robot in vertical and horizontal planes comprise the basis for shape exploration. Space is a factor which further disguises movement by direction, dimension, level, path, and focus. The tempo (rate of speed) of the movement and the subsequent rhythmic patterns of motion are paramount concerns in the development of aesthetic sequences of robotic movement. The elements of force, that is, energy, effort, weight, and dynamics, relate to the intensity of movement. The quality of movement then results when time, tempo, and intensity are treated in certain relation to both gravity and space.

In Robot Choreography, this programming has focused on achieving aesthetic movement, smoothing and softening the cold, hard Cartesian angularity of a robot's "natural" motions into more organic humanistic forms. Precise synchronization of movement phrases with musical accompaniment has been a salient feature of all compositions with harsh lines and transitions, staccato actions and constant speeds replaced by sustained patterns modulated for expressiveness.[7]

PROGRAMMING TECHNIQUES

A program for robot choreography consists of various routines and subroutines. Individual points in space are named and recorded as movement positions. These points are linked together into movement phrases which constitute the routines and subroutines. Individual points in space are recorded with specific names indicated in the steps of each subroutine. The qualitative aspect of the movement is achieved by varying speeds between point which can create various rhythmic patterns. The robot becomes a vehicle of expression for the human choreographer.

CREATIVE EXPRESSION

Performing artists work with various tools and media. The robot as an artistic tool does raise issues. An artist often feels and intimacy and compassion for a new creation; that is, the action of expression surrounds the development of art. The feelings and compassion of an artist are often wrapped up in the work of art. Robot Choreography does present an unusual approach for the artist, as the choreographer is actually expressing ideas through the computer with the artist twice removed. The choreographer must translate the artistic vision into the computer language in to manipulate the robot.

The beauty of teaching a robot to dance helps to breakdown rhythm into its smallest segments of movement (point-to-point) and linking those segments into larger movement phrases via the computer programming techniques. Choreographers often teach in phrases or chunks of movement but the beauty of the robot is the linking and recording of the phrases into computer programs. Time motion photography is a technique that captures many frames of movement in one still photography which presents the essence of robot motion from mechanical motion, human motion, and Robot Choreography.

The artistry of photographer, Mike Mandel captured the "work" of a robot, the "work of a human," and the "dance" of a robot with this time-motion photographic technique. A light was placed in the "end effector" (hand) of the robot to capture the movement sequences for the camera. The broken lines in Photos 1, 2, and 3 indicate the paths of movement and the duration of the time. The efficient moves of a robot preparing a meal in standard robot mechanical movement shows efficiency characterized by a constant speed, straight lines, and angular transitions in Photo 1. Photo 2 represents a human emptying a refrigerator with varying speeds, curvilinear movements and transitions, thus illustrating the human touch. The robot dancing a programmed dance resembles the human movements of varying speeds, curvilinear movement paths, and transitions in Photo 3. Clearly, the "dancing robot" shows a stark difference in movement paths, speeds, and transitions.

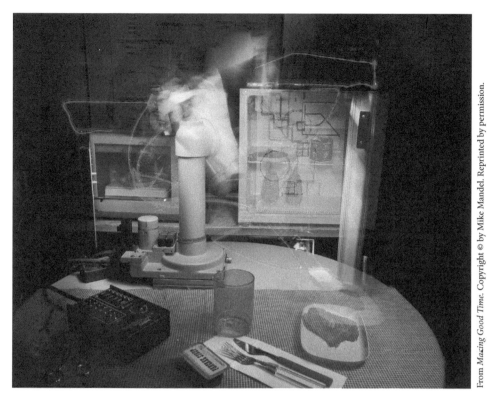

Robot prepares a meal

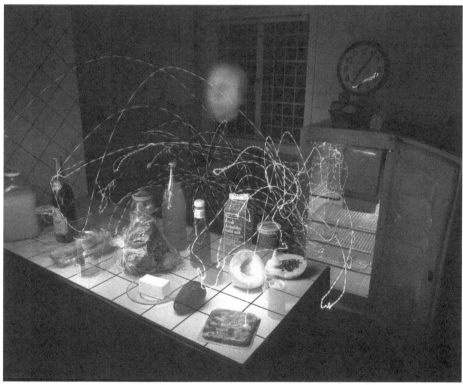

Human empties a refrigerator

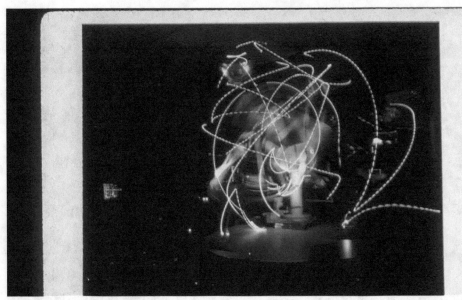

Robot dancing

Programming a robot to dance with humanlike movement helps in understanding the aspects of rhythm. In order to teach a robot to dance, the elements of rhythm and timing are broken down into small point-to-point positions. The more points in space, the more control of the timing and the quality of the movement with the changing variable of speed being a factor. The point-to-point sequences are linked together with in the computer program with individual steps and varying time intervals. The overall speed of the robot may vary based on the choreography. The acceleration or deceleration of the system speed works to create more humanlike actions by using variable speeds in the point-to-point transitions. Once the entire choreographic piece is completely programmed, the entire dance runs in a stream of continuous path movement. The robot never stops with the motors running even when paused or in a hesitation in the sequence. This state of "idle motion" similarly reflects the human dancer. Remember, all movement has a rhythmic pattern whether human or robot.

Robot Choreography demonstrates both interdisciplinary thinking and collaborative work merging art and technology. Robot dancing is part of entertainment and advertising in the 21st century, as the technology gives more sophisticated robot dancers with greater audience acceptance.

UTILIZING TECHNOLOGY TO AID THE DANCER

The application of technology to assist in training, performance, rehearsal, and injury prevention of dancer is a recent example of pilot study conducted at Cedars-Sinai Medical Center in Los Angeles, California. The aspect of overtrain-

ing is common in dance training. Dancers tend to train and rehearse too much with dance injuries often occurring as a result of fatigue in the performer.

Dancers tend to escalate the intensity and duration of rehearsals just prior to performance with repetition of the same choreographic sequences. This hazardous training procedure of dancers is counterproductive as it often induces fatigue and injury just prior to the show. These injuries have both a physical and fiscal impact on both the dancer and the dance company. Research into preventative strategies that reduce the risk of interest are of great interest and the current technology offer alternatives. A pilot study united the expertise of biomechanics expert and Research Scientist, Melodie Metzger, PhD, with my dance knowledge in collaboration at the Cedars-Sinai/USC Glorya Kaufman Dance Medicine Center to explore an alternative to rehearsal training.

In this pilot project, mixed reality was used to create a nonphysical training program that allows the dancer to visually and mentally train in a realistic and immersive environment while resting the dancer's body in preparation for the event. Dance imagery, the ability to rehearse or envision a performance mentally in the absence of physical movement, has been a part of teaching and training for decades.[8,9] Adding an immersive 3D experience either a virtual or augmented reality system creates a powerful training tool capable of reducing the physical workload leading up to a performance.

The performance venue scene is replicated with the stage recreated with the tools of photogrammetry to map the performance venue. The computer aids in recreating all the points in space of the stage from the dancer's perspective and the 3D environment is created for the avatar performance.

The rehearsal protocol involves the dancer wearing the Mixed Reality googles to visually and cognitively rehearse the choreography. This preliminary work lends way to further work and new development in dance performance training in reducing fatigue and injury in dance from overtraining.

THOUGHT EXERCISES FOR CHAPTER 8

- What applications can you think of for a dancing robot?
- What can humans learn from robots?
- How may rhythm help with efficiency in movement?
- How would you incorporate a robot into a dance performance?
- After practicing a dance sequence or movement skill, try to visualize yourself performing that sequence at a level of optimal performance.

MUSINGS

This interdisciplinary journey is about connections and collaborations. This is a great time to reflect on the ongoing growth and expansion of dance in culture as an art form. The technology is providing new tools for artistic expression and the artist are devising new ways to utilize those tools. The vast resources of the continually advancing technologies bring new opportunities for dance to people of all ages and abilities. Perhaps, the most important element to consider is the human aspect in that human–machine connection through technology married to the liberal arts and the humanities.

ENDNOTES

1. Herbert Reed, *Art and Industry: The Principles of Industrial Design,* Horizon Press: New York, 1961, p. 44.
2. Richard C. Dorf, *Technology, Society and Man,* Boyd and Fraser Publishers: San Francisco, 1974, p. 107.
3. Margo K. Apostolos, *Exploring User Acceptance of a Robotic Arm: A Multidisciplinary Case Study,* Doctoral Dissertation, Stanford University: December 1984.
4. Margo K. Apostolos, Robot Choreography: Kinesthetic Creativity at the Mind. *Metal Interface,* Presence 1 (1) 1992, pp. 149–150.
5. Apostolos, M. K., M. Littman, S. Lang, D. Handelman, and J. Gelfand, Robot Choreography: An Artistic-Scientific Connection. *Computers & Mathematics with Application* Vol. 12 No. 1, 1996, pp. 1–4.
6. Ibid.
7. Ibid.
8. Gildea J. E., Van Den Hoorn, W., Hides, J. A., and Hodges, P. W. Trunk Dynamics Are Impaired in ballet Dancers with Back Pain but Improve with Imagery, *Medicine & Science in Sports & Exercise* 2015, pp. 1665–1671.
9. Pavlikk. Nordin-Bates S. Imagery in Dance: A Literature Review. *Journal of Dance Medicine and Science* 2016, pp. 51–63.

Health and Fitness Through Dance

> Dancers are the athletes of God.
> —Albert Einstein, theoretical physicist

Dance is both and an art and a science: art is the expressive activity and science is the physical aspect of training. Sport training relies on the science of movement, while dance features an aesthetic of movement. Dance training embraces the values of science to enhance human performance and sport enjoys the values of dance in cross training. Dancers are considered to be athletes and athletes are training with dance.[1] From the importance of dance in the physical training of the ancient Greek athletes and soldiers to today's physical fitness trends, this chapter highlights the benefits of dance in physical education and fitness training.

CONCEPT: PHYSICAL EDUCATION

Physical education is a specialized area within the broad spectrum of education. Universities and colleges still offer a Physical Education major or minor. Physical Education, within the realm of education, seeks to promote: education of movement, education for movement, and education through movement utilizing fundamental skills that are part of everyday living such as running, jumping, climbing, throwing, lifting, dodging, and in land, airborne, and aquatic environments. The goal is to train each individual to understand the mechanics of motion and train for healthy living and optimal performance.

In 1960, President-Elect John F. Kennedy recognized the importance of physical activity for all people in an article for *Sports Illustrated* titled the "Soft American." President Kennedy stated, "For physical fitness is not only one of the most important keys to a healthy body, it is the basis of dynamic and creative intellectual activity."[2] The young, active Kennedy recognized the importance of physical training for mind and body fitness. Kennedy's "Soft American" connected the weak ess of a nation to the vitality of the people with overtones of Plato's mind/body dualism. Kennedy states, "...such softness on the part of individual citizens can help strip and destroy the vitality of the nation." He continues:

> For the physical vigor of our citizens is one of America's most precious resource. If we waste and neglect that resource, if we allow it to dwindle and grow soft, then we will destroy much of our ability to meet the great and vial challenges which confront our people. We will be unable to realize our full potential as a nation.

This concept of the "Soft American" recognizes the subtle and complex relation within the concept of mind/body dualism. Kennedy stated, " For physical fitness is not only one of the most important keys to a healthy body, it is the basis of dynamic and creative intellectual activity."[3] The inclusion of dance within physical education broadens the scope of the mind/body training to the physical body and creative mind.

Physical fitness impacts daily life for people of all ages with an individual's ability to meet the demands of a specific task, whether in performance, competition, or activities of everyday life. A certain level of fitness is required in activities in daily life with a greater degree of physical fitness needed to meet the levels of performance needed for sport competition and dance performance. The fundamental components of physical fitness include; muscle function, aerobic and anaerobic capabilities, muscle strength, muscle power, joint mobility, flexibility, balance, endurance, agility, and body composition. A skilled dancer or athlete works to develop these fitness components to an optimal level for performance and competition. One does not need to be a professional dancer or professional athlete to attain and maintain an optimal level of physical fitness to enhance the quality of life.

Physical education is a specialized area, within a broad category of education, that promotes physical activity as a "way of life" to enhance the quality of living. While physical education is concerned with the totality of human development including the physical, mental, and social dimension, dance education is often part of the physical education programs in the schools. This notion of dance, as education, goes back to Ancient Greece and Plato's School with dance as physical training for athletes and warriors. Dance is a fundamental form of movement which may be applied to other activities and sports and sometimes called the mother of all sports.

The beginning of dance education in the United States links dance with physical education in the early twentieth century. This educational link of dance and physical education is particularly important to reinforce Plato's notion of dance as physical training for athletes and warriors. People enjoy the freedom of dance movement to express feeling whether on stage or in solitude, dance brings a rhythm and harmony to the mind, body, and spirit.

In the twenty-first century, dance is still found in physical education programs across the United States, both at the elementary and secondary levels as part of the curriculum, along with various sports and health education activities. Dance remains in many physical education departments, theater, and performing arts programs, spreading the message of dance as physical activity for all ages and levels and abilities. Dance is movement and movement is life.

HEALTH AND FITNESS THROUGH DANCE

TRAINING PRINCIPLES

Fundamental fitness training principles include: specificity, cross training, overload principle, over training, periodization training, resistance training, and cardiovascular training. Proper training is essential for a healthy and fit lifestyle. Dance activity is both fun and effective for fitness training.[4]

Specificity

Specificity training includes the work of specific muscles groups, muscle actions, and speed designed for particular activities. Primarily, elite performers train specifically for their particular event become the best at a particular event. For example, to become a prima ballerina, one must train in ballet or world-class swimmer must train in the water engaged environment. Dance, a fundamental training, may enhance many other activities.

Cross-Training

The idea of cross-training may appear contradictory to specificity training, although teachers and coaches recognize the value of cross-training. Dance becomes a great fundamental cross-training that may enhance many other activities. Generally, a cross-training activity should provide both a mental and physical change for the performer. Examples of cross-training activities include swimming, cycling, walking, rowing, and elliptical training. A change in environment adds to the psychological benefits of cross-training activities. Dancers may even cross-train within dance, such as a ballet dancer training with hip-hop or ballroom dance.

Overload Principle

The principle of overload applies in effective training for both dance and sport. Growth and improvement are possible with increased training. Performance stagnates when doing the same activity day after day. Increasing the intensity in training aids in strength development and adds a challenge for the performer. Both strength and endurance benefit from adding repetitions and the volume of the activity. An increase in the frequency adds to endurance and strength by merely increasing the times per week for the training. However, beware of the trap of overtraining.

Overtraining

Injuries to dancers are quite often the result of overtraining. All performers, whether in dance or sport, need to recognize the signs of overtraining, such as exhaustion, fatigue, counterproductivity, and injury. Avoid overtraining by incorporating rest in the training programs. Rest is necessary, especially with training all year. Rest allows the mind and muscles to recover.

Periodization Training

Periodization training is highly recommended for individuals of all ages and lifestyles. This popular training program is used by professional athletes throughout the world. The individual plans a training program for optimal performance. Typically, periodization programs work with an approximately eight-week program using training cycles for peak performance outcomes. The training cycles include the following phases:
- Preparatory phase
- Buildup
- Maintenance
- Taper

In the preparatory phase, the performer begins with light training, followed by intensive training in the buildup. Once the performer reaches a peak, the maintenance phase begins and moderate activity begins. Prior to the event (dance performance, sport competition), the taper begins, which is the phase of reduced physical expenditure. These phases range individually with the performer identifying their peak performance and regulating the maintenance and the taper with the guidance of the dance teacher or coach.

Resistance Training and Cardiovascular Fitness

Whether a dancer or an athlete, resistance training (eccentric and concentric) working of the muscles assists in building and maintaining muscle strength. Dance resistance exercises often utilize muscle movement with light resistance

to sculpt the muscles. Physical fitness recommends basic cardiovascular training at least three times per week for 20 to 30 minutes each workout to elevate and maintain the heart rate. Walking, cycling, swimming, and running are excellent cardiovascular activities and are important to add to dance training.

PREPARING FOR ACTIVITY

The preparation for activity does require attention, as the individual is transitioning from one activity to another; perhaps from sedentary to active, from one activity to another, or from one environment to another. The dancer may need to transition between techniques—from ballet to hip-hop. A student may transition from sitting in class to the studio or sport venue. A swimmer, diver, water polo player, or synchronized swimmer may transition from land to water.

In any event, this preparation involves the physiological, to get body ready; the psychophysiological, to get the feel; and the psychological, to get the mind ready. Another helpful hint is to get into the costume/uniform for the event which sets the stage for the transition to activity.

MOVEMENT/SPORTS SIMILARITY

While sports and activities of daily life may incorporate very specific skills, there is a similarity of actions found in all movements. This movement similarity is found in dance training. The similarity in dance and sport is visible in movement through the shared physical components, including but not limited to flexibility, agility, balance, coordination, timing, and strength. Athletes train with extensive sport-specific conditioning programs, working with these physical components tailored to their sport, particular position, or task in the competition. Dance training works with these similar physical components for training in the dance setting with an understanding of sport specificity. Sport similarity identifies movement patterns similar in sport and dance training with a slight shift in thinking from sport specificity. Specificity applies to the specific sport, while similarity includes basic movements found in all movements.[5]

SIMPLICITY OF FUNDAMENTAL MOVEMENTS

Quite simply, the fundamental of movement include the basic movements of bending (flexion), stretching (extension), and twisting (rotation). The simplicity of these movements allows an opportunity for an individual to identify an individual awareness of posture and alignment through body linkage or connection of the body forces and joint reactions contributing to the fluidity in movement. A focus on

these fundamental actions presents a basis for movements in sport skills, dance, and activities of everyday life. The similarity of these fundamental movements is found in dance, sport, and activities of everyday life.

THE ATHLETE AS DANCER

Dance training introduces the beauty and freedom of dance movement in the relaxing atmosphere of a dance studio. A dance studio offers an open space with mirrors and musical accompaniment in an atmosphere contrasting the surfaces and competitions of gameplay. For athletes, this neutral space contributes to an experience without rules and regulations beyond the boundaries of most sports. The athletes

Viktor Gladkov/Shutterstock.com

Bending

tommaso lizzul/Shutterstock.com

Stretching

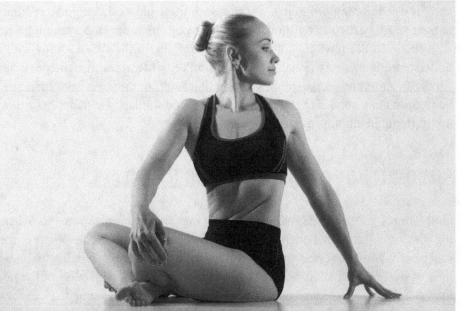

fizkes/Shutterstock.com

Twisting

work with fundamental movements in a unique experience, contributing to the perceptions leading to kinesthetic awareness and rhythmic awareness in an experience of movement for the movement's sake without the focus of winning.

MIND AND BODY WORK

Dance often uses deep breathing exercise to quiet the mind and body and prepare the dancer/athlete for the dance experience. The quiet, supine breathing is particularly helpful for athletes during the competitive season, whether before or after competition. The cognitive benefits of students studying dance presents a challenging learning experience for independent thinking. Trained dancers learn to think differently; that is, the instantaneous interpretation of visual, auditory, tactile, and spatial/directional cues encourage a different way of processing information and translating into movement. These simple examples of movement experiences in dance training highlight the exploration of the freedom in movement. Dance allows the students to express themselves and provides a creative platform for their inner feelings.

POSTURE AND ALIGNMENT

The floor work in dance highlights alignment and posture from head to toe, as the dancer lies flat on the floor without the resistance of the force of gravity. This exercise is non-weight-bearing, and the dancer listens to their bodies, breath, and feelings. Lying on the floor works on body awareness and alignment, with an introduction to the basic concepts of movement articulations of the fundamental movements in a very relaxed format. The importance of proper placement and form is crucial in understanding proper posture and alignment. The technical work assists the athletes to understand the intricate work of the dancer. Simply, standing and bending the knees is not taken for granted in dance, and dancers work to perfect this fundamental movement.

The student transfers the posture and alignment from the zero gravity of lying on the floor to the upright, weight-bearing standing position. The standing exercises face the mirrors in a progression of the body alignment and placement from the floor sequences to a standing position with the mirrors providing immediate visual feedback. In the standing center floor exercises, the large muscle movements integrate with breath control and the body linkage connects rhythmically for fluid motion with musical accompaniment, often of a medium tempo and clear underlying beat. The arms work through the torso, and various sequences are developed to focus on balance, coordination, and strength.

Various physical components of flexibility, strength, coordination, agility, balance, and timing are important elements of dance training. In addition, dance

provides a foundation for all movements and focuses on correct body mechanics, body awareness, postural alignment, body linkage, and fluidity in movement to enhance an individual's movement in and out the studio. Clearly, dance training is a foundation of fundamental movements for athletes in all sports and for life. The importance of dance training comes with the ability to transfer the dance skill back to other activities in sport and everyday life.[6]

KINESTHETIC AWARENESS AND RHYTHMIC AWARENESS

The independent variables in dance are uniquely training for kinesthetic awareness and rhythmic awareness.[7] In dance training, the student focuses on their individual body in space and time. The feelings are personal and intimate, with the tangible outcome being the individual in better connection with their own mind and body feelings. Thus, in the dance studio, the student feels their own movements. Body awareness and timing are fundamental elements in both dance and sport contributing to a personal and intimate experience for the athlete. Physical abilities are personal traits that remain fundamental to the athlete in motor skill development.

RHYTHMIC AWARENESS

Rhythm is a unique variable in dance training. All movements follow rhythmic patterns, whether in dance studios, athletic venues, or activities of everyday life. These patterns of movement are seen, heard, and felt by the athlete, coach, and spectator. Dancers and athletes move through sport skills with specific timing and accents in movement sequences. The dance student finds their own intrinsic rhythm, which is often guided by an extrinsic rhythm of musical accompaniment.[8]

KINESTHETIC AWARENESS

Kinesthetic awareness is the mind and body connection of knowing where your body is in space. This experience of body positioning is of particular importance to the dancer and the athlete. Proprioception, an aspect of kinesthetic awareness, is seen in the individual ability to perceive muscle motion, weight transfer, body position, and spatial orientation corresponding with body control, alignment, placement, posture, and balance. The kinesthetic sense influences these factors and works with the elements of force and direction in movement control. The effortless, efficient, and flawless movement in human performance is a result of this internal navigating sensation. Quite simply, an ability of feeling where your body is in space and not a skill that is taught but rather an experience demonstrated through the performance. The performer does not move to make kinesthetic awareness happen, but rather moves as a result of kinesthetic awareness.[9]

In summary, all movements have a rhythmic pattern. In dance, the focus of the motor skill activity works with external and internal rhythms of the dancer. Dance is an effective tool in training to find extrinsic and intrinsic beats and tempos to transfer into their own body and into their sport skills. This personal and intimate experience of sound and feeling is dependent on kinesthetic awareness.

FACTS AND FEELINGS

Whether dancer or athlete, a key to optimal performance is discipline. The dedication to training incorporates sleep, nutrition, physical activity, social and emotional support, and balance, just to name a few. Keeping a regular journal often helps to reflect and gauge the ups and downs in everyday life. Dancers and athletes are well disciplined, and the logging of "facts and feelings" helps as a guide or even a barometer of one's well-being. This log aids in self-understanding and adjustments based on the account of simple factual information and personal feelings.

The "facts" are things like foods, mealtimes, hydration, rest hours of sleep daily, training and cross-training activities, injuries, and special events (parties, concerts, etc.). The "feelings" include energy, disposition, productivity fatigue, irritability, enthusiasm, and stress. Reflecting on your own daily "facts and feelings" may be a helpful tool in self-evaluation, leading to a better lifestyle through whole mind and body conditioning. Remember your state of mind affects your training. Performance outcomes often represent the balance of facts and feelings.

THOUGHT EXERCISES FOR CHAPTER 9

- Keep a journal of your daily "facts and feelings."
- Experience a new movement activity in either dance or sport.
- Find the dance in a specific sport.
- Develop your own periodization training progam.

MUSINGS

As a lifelong student and teacher of both physical education and dance, the duality of the two have been reinforced throughout my life. Dance training made me a better athlete, and sport made me a better dancer. This experiential learning process reinforces my belief in the coexistence of dance and sport in training. My personal interdisciplinary journey profited from the duality of dance and sport through the study of both art and science, which opened my mind to the coupling of methodologies for optimal results. In the words of Einstein, "Dancers are the athletes of God."

ENDNOTES

1. Margo K. Apostolos, *Dance For Sports: A Practical Guide* (Oxford University Press: New York, 2019).
2. John F. Kennedy, "The Soft American," *Sports Illustrated*, December 26, 1960.
3. Ibid.
4. Margo K. Apostolos, *Lectures from Health and Fitness Through Dance*, University of Southern California. Kaufman School of Dance.
5. Margo K. Apostolos, *Dance For Sports: A Practical Guide* (Oxford University Press, New York, 2019), 7–25.
6. Ibid., pp. 27–38.
7. Ibid., pp. 39–61.
8. Ibid., pp. 49–61.
9. Ibid., pp. 49–61.

Beyond the Steps

Life is the dancer and
You are the dance.
—Eckhart Tolle, Author

This chapter presents several examples of interdisciplinary connections, collaborations, and discoveries with dance as a catalyst. Each semester my USC students present their own research studies linking dance with any other topic of their interest. The students' discoveries are far more interesting than my lectures. The fresh ideas that emerge offer many connections collaborations, and some very exciting discoveries. The link between dance and another area expands the ideas and opportunities for dancers often beyond the studio and the stage and into some very interesting places.

CONCEPTS: CONNECTIONS, COLLABORATION, AND DISCOVERY

Connections are links or relationships bringing together people or ideas to broaden the scope of our thinking and expand the role of dance in society. Collaborations, whether teams, community, network, or virtual, imply people working together for a common purpose. Connections and collaborations may lead to new innovative discoveries. Discovery uncovers something new, often timely, and creates new findings. In the 1980s, robot choreography was a discovery that began with a connection between dance and robotics that was fostered by the collaboration of mechanical engineers with dance, which still continues today.

DANCE AND MEDICINE

The similarity between dance and sport highlights the collaboration of dance and medicine—a natural connection. The field of sports medicine includes orthopedics and physical therapy for the diagnosis, treatment, care, and prevention of injuries for sports-related activities. Dance medicine applies sports medicine for dancers. While an injury may appear the same in both a dancer and an athlete, the nature of the activity impacts the care, treatment, and recovery for the patient. An injured dancer needs a medical diagnosis, then a recovery plan is recommended for treatment. As with sport injuries, the dance injuries need specialized attention for recovery back to optimal performance level.

Athletic trainers are certified and licensed health-care professionals within sports medicine. Many sports teams, from the professional, universities, colleges, and high schools, include an athletic training staff to work with specific sports, both in practice and competition. Dance needs to promote the inclusion of athletic trainers in training, rehearsal, and performance. The specialization of applying dance to health and healing is widespread. The merging of dance and sports medicine recognizes that the needs of the dancer are similar to those of the athlete.

DANCE THERAPY, PHYSICAL THERAPY, AND OCCUPATIONAL THERAPY

The American Dance Therapy Association (ADTA) defines dance/movement therapy as the psychotherapeutic use of movement to promote emotional, social, cognitive, and physical integration of the individual.[1] Dance therapy promotes dance as therapy, which is a distinct difference from the fields of physical therapy and occupational therapy. Physical therapy preserves, enhances, or restores movement and physical function impaired or threatened by disease, injury, or disability and that utilizes therapeutic exercise, physical modalities, assistive devices, and patient education and training. Physical therapy for the dancer is specific with the therapist understanding the conditions and demands of dance.[2] Occupational therapy is therapy based on the engagement in meaningful activities of daily life (such as self-care skills, education, work, or social interaction), especially to enable or encourage participation in such activities despite impairments or limitations in physical and mental functioning.[3] Dance, as an occupation, meets specific needs and outcomes that may be addressed through occupational therapy.

BIOMEDICAL ENGINEERING

The union of dance and engineering offers opportunities to link dance with rehabilitation, therapy, and virtual alternatives. For example, the development of prosthetic devices for dance and sport partners the latest technology and materials with movement to design devices for both dance and sport. Prosthetic devices have been designed for dance amputees to perform and continue the joy of dance.

The merging of dance and mixed reality creates virtual dance environments for both physically impaired dancers and those dancers working through injuries or reducing the fatigue of excessive rehearsal prior to performances.

THE BUSINESS OF DANCE

Dance training is a business enterprise for the dancer and dance teachers. Dance has become big business, although the dancer is not always the one that is making the most money. Dance training is costly with the price of the lessons, dance apparel, and shoes, with competitive performance opportunities. A private dance studio may be very lucrative based on the quality of the instruction and the location. Proper dance training requires specific training and rehearsal specifications. For example, a dance studio should have proper flooring (sprung floor) to adhere to the dance training and rehearsal needs. Dance injuries result from extensive training and performance on improper flooring.

The costs of dance production are extensive from the cost of the theater space, lighting, costumes, stage crew, house management crew, advertisement, and so on. Thus, ticket pricing and sales try to offset these expenses. The most successful dance companies must maintain excellent business management.

Viktoriia Hnatiuk/Shutterstock.com

Dance
Biomedical
Prosthetics

DANCE CONVENTIONS AND COMPETITIONS

The big business of dance conventions and competitions impacts the training and performance for young dancers. Currently, dance conventions are held in many cities throughout the year and offer top-level instruction. A highlight of these conventions is often a competition with cash prizes awarded. Each performance group submits an entry fee for the competition and professional dancers serve on a panel of judges. The business of dance conventions contributes the introduction and spread of dance throughout our country to young dancers and the employment of dance teachers working at the conventions and competitions.

ADVERTISING

The world of advertisement has realized that dance sells. If you present your product in an artistic setting with dance and music, it will certainly capture the attention of the viewer. The safety protocol instructions on many airlines is choreographed with dancers to assure the attention of the passengers. Rather than listening to the flight attendants speak over the audio system, a lively dance video of the information grabs the attention of the passengers. A message delivered through dance is more appealing for the viewer. The sheer beauty of bodies in motion, particularly trained dancers, make advertising an art. In addition, even a billboard on the highway may feature a photograph of dancers to promote a product or production. Again, eye-catching with an aesthetic appeal for the viewer.

FASHION

The link between dance and the fashion industry is extremely strong. Between the rehearsal clothing and performance attire, dancers invest in their wardrobe. Dance apparel has become very trendy for both dancers and even nondancers. Even large sport manufactures have discovered that dance sells. By the way, you do not have to dance to wear dance fashion, as much of society today enjoys comfort and style of dancewear. Dance is universal and everyone enjoys dance, so dance attire is for everyone to enjoy. Just like dance costumes, dancewear is designed for movement and tends to be very comfortable; dancewear has become everyday streetwear.

MATHEMATICS AND PHYSICS

The art of dance and the science of mathematics may not appear to be compatible, although they have many commonalities. The aspects of rhythm and timing are often measured with numerical counting, while geometry works with space

and shape. Teaching mathematics and geometry can be fun for young children by incorporating dance as a teaching tool. Whether counting the musical rhythms through movement or making geometric shapes in space, dance provides a vehicle for teaching mathematics.

Combining mathematics and physics, the movement analysis of dance skills can be dissected and measured often coupled with biomechanical analysis of movement sequences. The science of mathematics, physics, and biomechanics works to improve dance skills and prevent dance injuries. Dancers may improve their own performance by understanding and applying principles of physics to the biomechanics of their own efficient and injury-free movements.

MOTOR LEARNING AND NEUROSCIENCE

Motor learning and motor control contribute to the teaching of both dance, sport, and skill acquisition. The chunking or breakdown of material for the student is a contributing factor in the motor learning process of transferring an action into a specific skill. Teaching any fine-tuned or large motor skill requires a motor-neural connections. The best teachers and coaches apply motor learning and motor control in the teaching of movement.

The field of neuroscience has embraced the dancer's brain. The dancer trains by learning movement through multisensory perception and remembering complicated choreography combined with rhythmic cues. Similarly, the branch of cognitive science examines the behavioral responses of the dancer in training and performance. The way dancers train is of interest to the researchers in cognitive and neuroscience, from remembering the intricate combinations and the choreography to the precision and timing of movements.

PSYCHOLOGY

Psychology for entertainment is a specialty that includes dealing with the problems of dancers, such as eating disorders, casting rejection, body image distortion, and financial issues. Often, the transition from dance performance to other work becomes embedded with issues of aging and body ailments. Several of my former students have gone on to specialize in this work.

SOCIAL MEDIA

Social media has created an explosion of dance and dancers of all ages and levels. The pandemic changed the platform for dance in both performance and teaching.

Teaching dance online is popular, although the quality of instruction needs to be constantly reviewed. The performance opportunities are seemingly endless with popular sites like YouTube. Many dance companies are presenting their performances via livestream, which significantly expands the viewing audience. Perhaps the next step in this ever-growing industry is better quality control in instruction. Teaching movement online may put the user at risk for potential injury without the immediate feedback from immediate instruction.

INTERNATIONAL RELATIONS, SOCIAL JUSTICE, AND LAW

Dance may serve to better understand the culture in a particular society. Whether on stage or in the streets, dance becomes a reflection of the people. At times, choreographers may present a message of the time in their work. For example, the opera *Nixon in China* featured the choreography of American choreographer Mark Morris, which told the story of former President Nixon's historic visit to China in the 1970s. More recently, the Chinese dance company Shen Yun tours the world to present the dance of China before communism.

SOCIAL JUSTICE

Does dance represent messages speaking of social justice through choreography? Remember the works of Alvin Ailey and Katherine Dunham; Ailey's Dance Company artistically established a place for Black dancers in ballet and Dunham's work spoke in a sociological landscape of the culture of the people of Haiti. Performers continue to express their powerful statements through dance both on the stage and in the streets.

LAW

Dance and the field of law are quite an intersection. Entertainment law is a specialty with the field and addresses situations that dancers and choreographers may encounter. From on-the-job injuries in rehearsal or performance to personal injuries that may interrupt the dance career, to copyright infringements of choreographed work, dance-related work is specialized. A lawyer with an understanding of the specific needs of the dance world is a treasure. A dancer may even serve as expert witness on movement and dance-related cases. Law is a field that dancers have transitioned into after their dancing days.

NATURE

Finding dance in nature is delightful because it is everywhere. Whether the dance of the bees around the hive, the methodical movement of a caterpillar, or the flow of the wind through the trees making both movement and sound, dance is movement and movement is life. The flow of the river, the ebb of the tides, the changing of the seasons are all time-related experiences. Two great examples of dance and nature came in the research of my students: one on dance and animals and another on dance and planets. These reports emphasized the elements of patterns and timing to actually see the dance in the animals and the plants. Another student explored astronomy and the stars "dancing" in the sky may be an aesthetic experience to many. The coupling of dance and astronomy presents visual patterns that may be re-created in dance and choreography.

GUDKOV ANDREY/Shutterstock.com

Dance and Nature

THOUGHT EXERCISES FOR CHAPTER 10

- Relate dance to your specific academic major.
- Find dance in nature.
- Create a dance experience in a culinary setting.
- Look for dance in unlikely places.

MUSINGS

We are the dancers in this dance of life. If you look around your world with an open, uncluttered mind, you will see the dance all around in people, objects, and nature. Finding a connection and venturing into a collaboration may lead to a new discovery. If you stumble on a topic that has little references or research available, this is wonderful because you may very well have stumbled on a new discovery. Remember that not all connections make great collaborations or new discoveries; however, venture into the interdisciplinary journey and begin by finding a connection with dance.

ENDNOTES

1. American Dance Therapy Association, www.adta.org
2. Merriam Webster, www.merriam.webster.com
3. Ibid.

Index